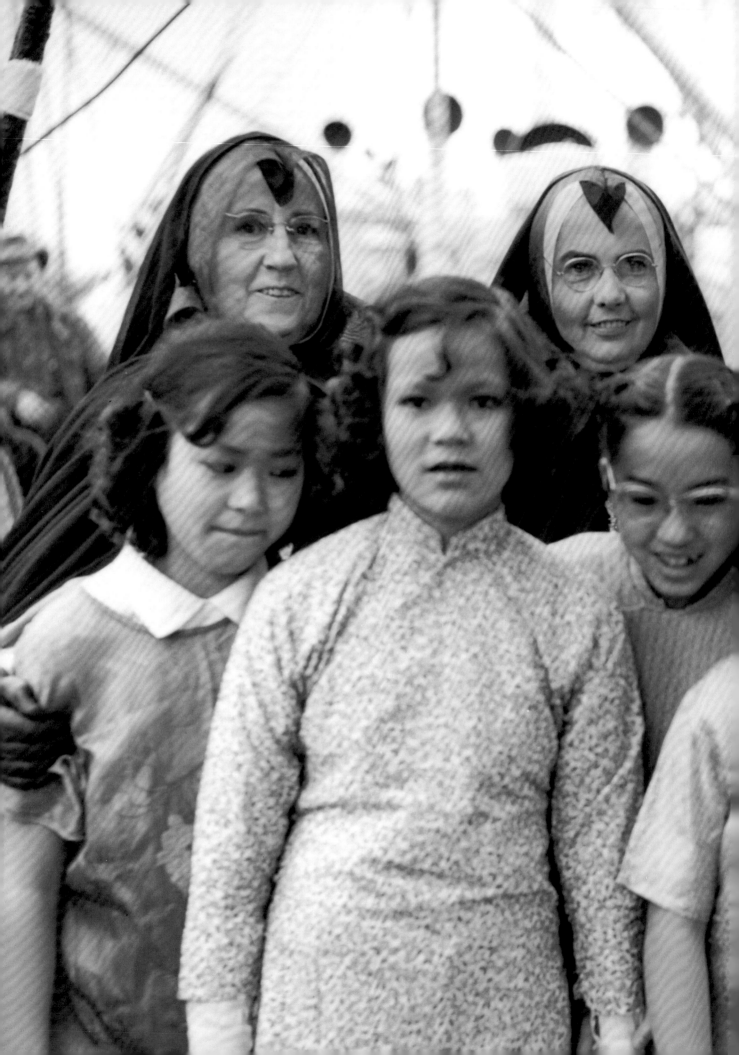

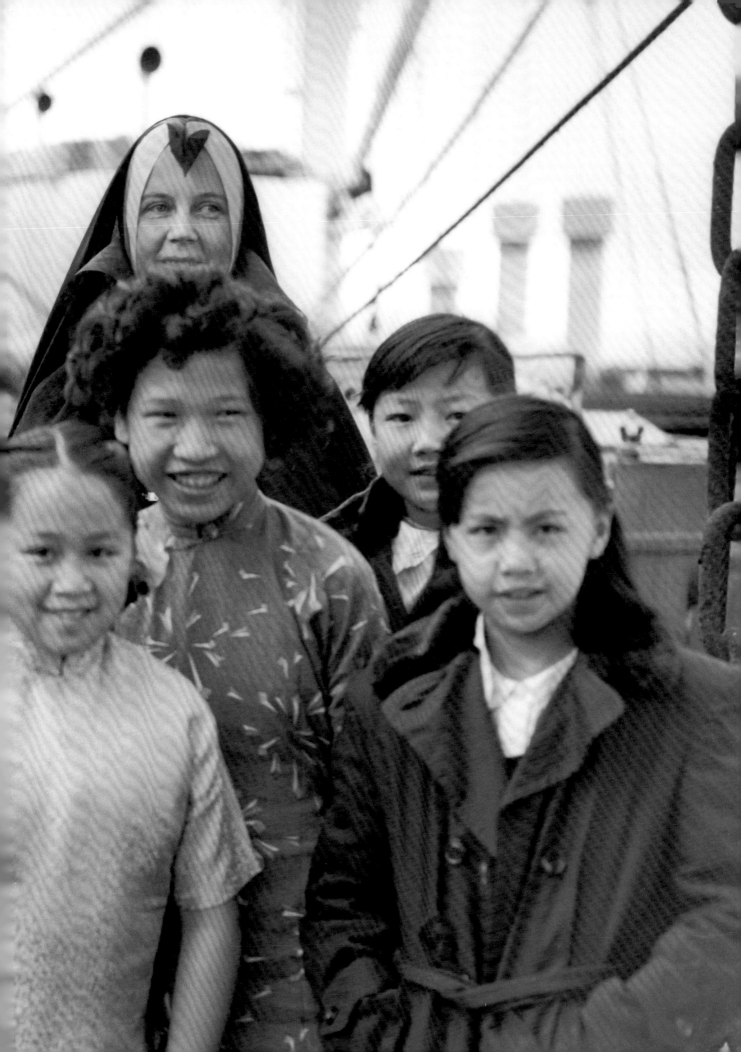

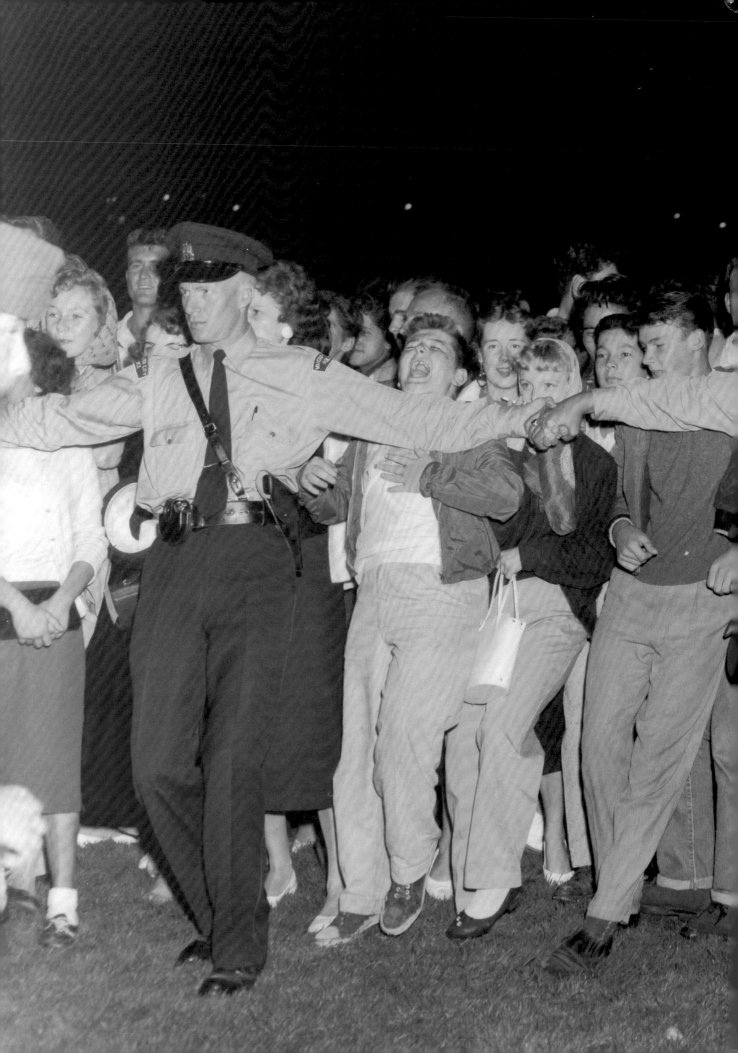

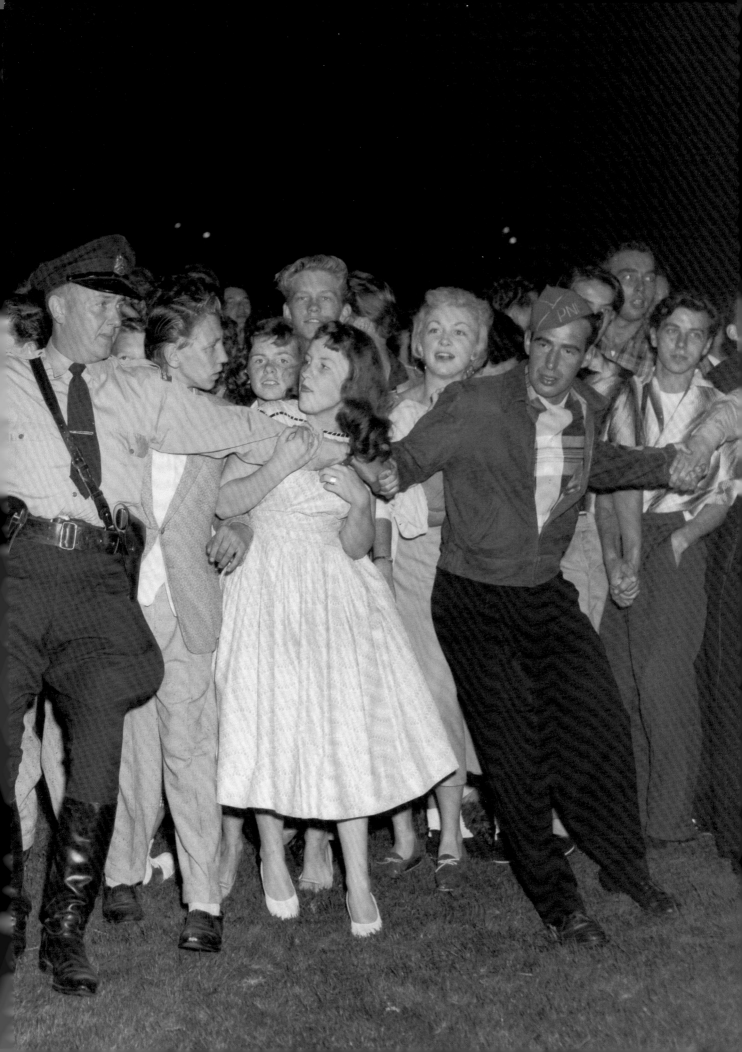

Anonymous, *"Mary Anne," Wife of Chief August Jack Khahtsalano, Squamish Tribe, Capilano Indian Reserve, North Vancouver, B.C.*, n.d., postcard, courtesy the North Vancouver Museum & Archives [3707].

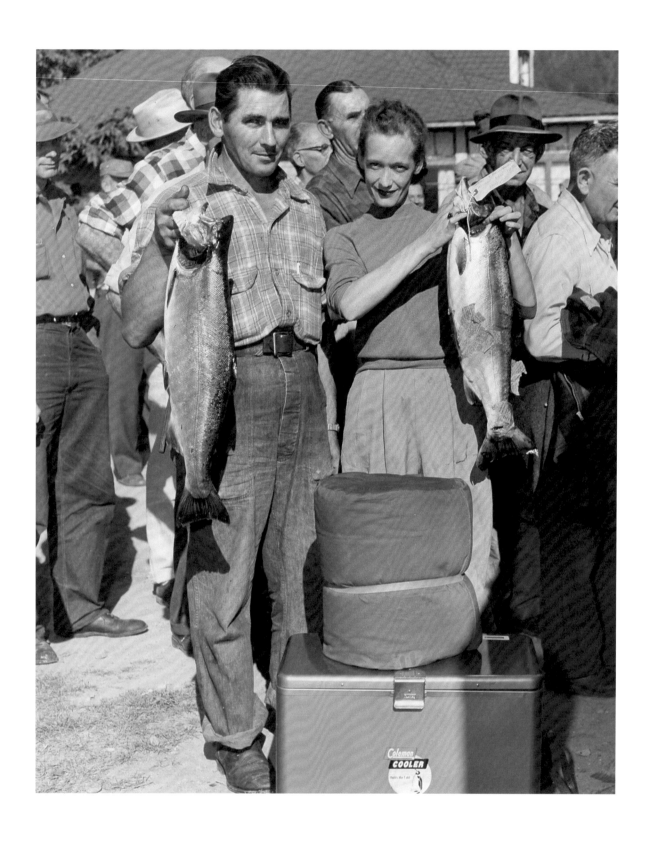

John McGinnis, *Burrard Dry Docks Annual Salmon Derby at Fishermen's Cove: Mrs. Kris Kristjonson*, 1957, courtesy North Vancouver Museum & Archives [27-1089].

Facing History

Portraits from Vancouver

Edited by Karen Love

with texts by

Robin Blaser, Colin Browne, Wayde Compton, Tom Cone, Nicole Gingras, Bruce Grenville, Karen Henry, Robert Hunter, Brian Jungen, Russell Keziere, Laiwan, Karen Love, Liz Magor, Roy Miki, Sarah Milroy, John O'Brian, Helga Pakasaar, Richard Rhodes, Marina Roy, Carol Sawyer, Bob Sherrin, Michael Turner, Betsy Warland, and Rita Wong

Presentation House Gallery | Arsenal Pulp Press

Chick Rice, *Tommy Crying*, 1993.

Work and Play

Public Life

Mind and Body

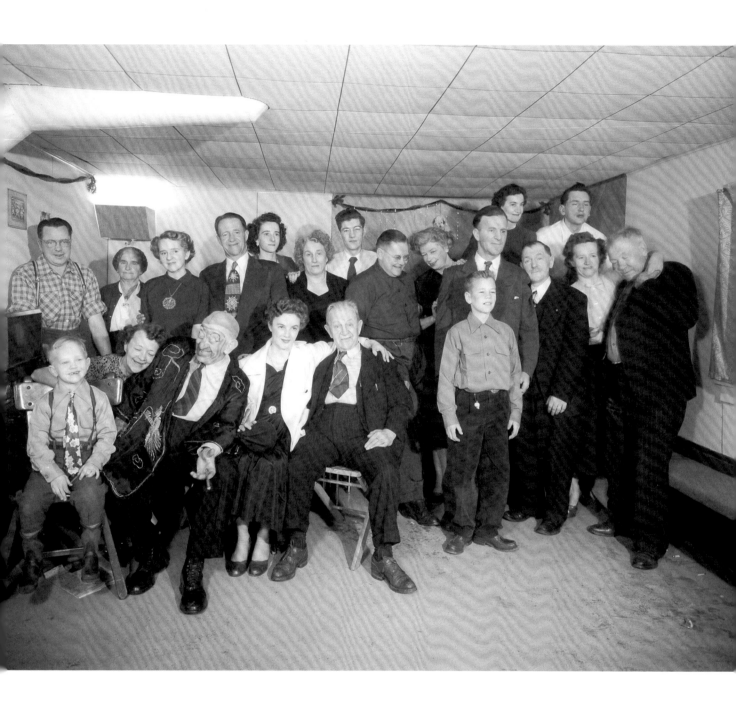

Percy Bentley/Dominion Photo Co., *McLellan Christmas Party at Mrs. Hamilton's*, January 1952, courtesy Vancouver Public Library/Special Collections [28676].

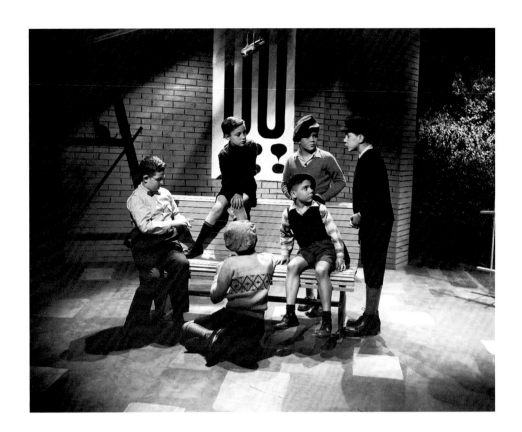

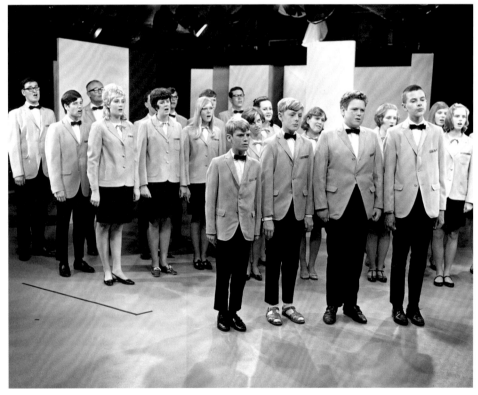

Alvin Armstrong. Top: *Hidden Pages: Emil and the Detectives*, November 7, 1956.
Bottom: *Chansons*, May 27, 1968. Production stills, courtesy CBC Vancouver.

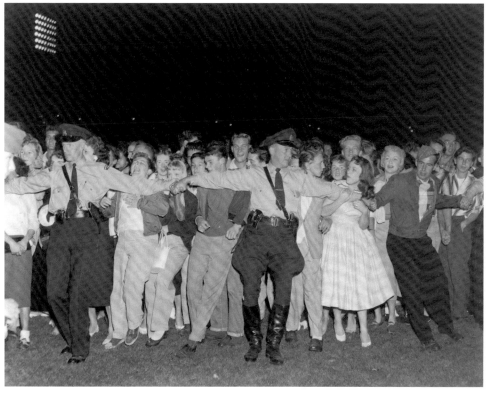

Top: Percy Bentley/Dominion Photo Co., *Presentation at John Oliver High School*, June 9, 1954.
Bottom: Bill Cunningham (?)/*The Province*, *Elvis Presley fans*, 1957, courtesy Pacific Newspaper
Group (Cunningham). Vancouver Public Library/Special Collections [61267; 29114].

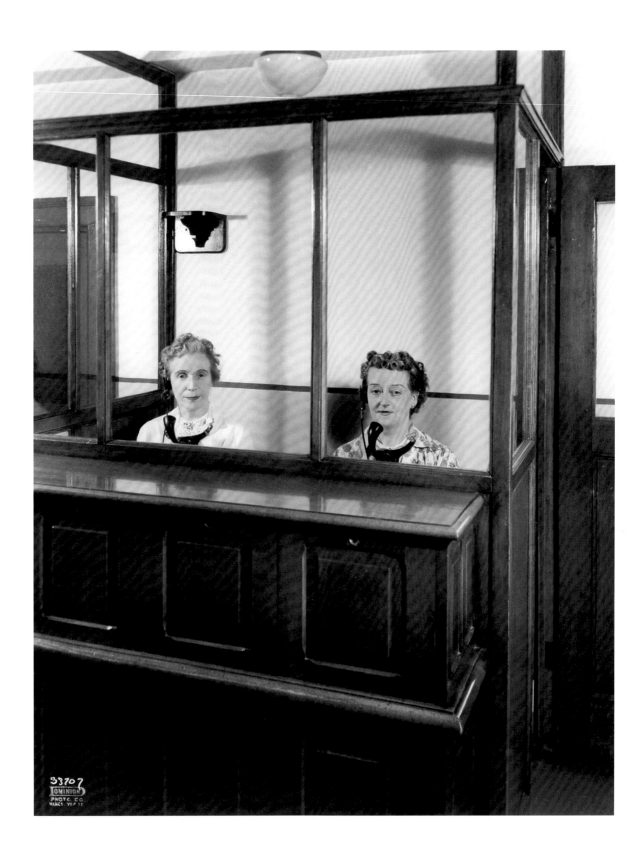

Percy Bentley/Dominion Photo Co., *B.C. Tel, operators at school*, February 21, 1950, courtesy Vancouver Public Library/Special Collections [28132].

Facing History

Karen Love

All that each person is, and experiences, and shall never experience, in body and in mind, all these things are differing expressions of himself and of one root, and are identical: not one of these things nor one of these persons is ever quite to be duplicated, nor replaced, nor has it ever quite had precedent: but each is a new and incommunicably tender life wounded in every breath, and almost as hardly killed as easily wounded; sustaining, for a while, without defence, the enormous assaults of the universe.[1]

I have been thinking about Vancouver's inhabitants, and whether it is possible to visually portray something 'true' about these unprecedented individuals, even about the population as a whole. As a long-time resident of the city who is nonetheless 'from away,' and as one who has the great benefit of being able to travel on occasion, I continue to marvel at Vancouver's distinct characteristics. Many of these are the compelling reasons for why it continues to be the place I call home: its municipal youthfulness, with an accompanying desire for sophistication despite its psychological and geographic distance from the 'centre'; its intimate and ambiguous relationship to nature, drenched as it is in images of sea and mountain (always visible!), yet struggling with the complex decisions related to resource extraction industries and our futures; its rich, constantly shifting cultural complexion, and a persistence in some quarters for acknowledging the not-so-nice aspects of the region's historic treatment of 'the other'; and of course its feverishly active arts community, fraught with saga, irony, and great talent.

I wonder if a selection of portraits from this city can relay the very mobile realities of urban living, that theatre of human endeavour which is cause for celebration, caution and action? Can a body's depiction imply the complex social, political, psychological map within which this person negotiates? As I assemble literally hundreds of images, derived from a dynamic, fifty-year time span, I hope they will resonate with our own lives, and perhaps, with larger global concerns. I think it is true that the 'universal,' when there is such a thing, lies in the consideration of many 'particulars,' and clearly this is how cities take shape. So just as each contribution in this book is important, so too is the fact of a multitude of voices, the complex mix conveying a pluralistic reality relevant to all communities.

Facing History gathers together images about people — portraits, broadly defined, made between 1950 and 2001 — by some of Vancouver's nationally and internationally well-known photo and media-based artists; by others who in some cases are at the very early stages of their career; and by a few from elsewhere who have lived in Vancouver and / or made major

projects about people in the city. Also included are image-makers whose motivation was for private, commercial or communications purposes. The selection emerged after a lot of sleuthing in small and large photographic archives, both public and private. It is hoped that in this mass of images the reader will sense the presence of a *population*.

Nineteen writers were invited to select an image or group of images to write about — something from the *Facing History* project which earnestly attracted their attention. They chose many different forms of writing for this task: poetry, fictional prose, art criticism, an alphabetical acrostic, documentary reportage, and more. In addition, a number of pre-existing texts have been included: statements by several artists about their reproduced work; Nicole Gingras's essay about Kate Craig's *Delicate Issue*, a key video work from the late 70s; and an excerpt from Robert Hunter's unpublished manuscript about the first Greenpeace voyage up the west coast of Canada to Amchitka Island in Alaska. Bob Sherrin's essay completes the book with observations related to the concept and practice of portraiture.

Two of the twentieth century's overriding themes — cultural identity and mobility/migration — weave through the book. The visual images, mostly two-dimensional photographs but including three-dimensional wall-mounted objects, videotapes, and a freestanding sculpture, are organized thematically. We consider family and community with a subsection on youth, all of which contribute to the shaping of identity; the crossover between art and life; questions of attribution, of memory and time; the phenomena of the street, work and play; public life and the development of political consciousness; the body and the life of the mind. The whole project is full of cross-references; if we were to link with string the ideas which connect with others, we would have a whacking great cat's cradle.

The linear, chronological format stands aside for a play of juxtaposition, emphasizing instead parallels in content. Thus "The Street" section begins with a possible portrait from the early 50s, of a man standing in front of the well-loved, now-disappeared Aristocratic restaurant at Granville and Broadway Streets. Who and/or what is being portrayed? As accompaniment we have the photographs of Foncie Pulice, whose street portraits were taken with a camera made from surplus war material and powered by a car battery. He is reported to have taken over twenty million photographs in three decades. Foncie's passers-by appear here in association with contemporary artist Ian Wallace's ongoing project, begun in 1987, titled *My Heroes in the Street*. This series honours the artist's colleagues, and contributes to a study of the individual's negotiation of the modern city and its 'forest of signs.' Michèle Smith's 2001 diptych series on public memorial benches, ubiquitous in the urban space, offers an image of the bench in its solitude and those who engage it, paired with an image representing its 'view:' we become the bench sitter, gazing out to sea and observing others. From there we shift to another scene of an outdoor bench, the focal point for a metaphoric night scene by CBC staff photographer Alvin Armstrong, a production still from a 1950s television drama called *An Aspect of Crime*,

and then to Bill Cunningham's newspaper photo of a man taken in custody (1960s?). Judy Radul's image/text work *Please* is a recent look at the ongoing performances of street life as found in panhandling or begging, in particular in the context of 'heritage' grandeur. Each thematic section in turn has this kind of crisscross of genre, chronology and visual strategy.

The conglomeration of image and word in this book contains many questions; each of us could accumulate our own lists. How far away or close up can we get from/to a person before our definition of portraiture disintegrates? How does the passage of time, the luxury of retrospect, alter our perception of each historic portrait, and which details or 'reminders' are triggering connections to today's world? Occasionally an image seems to be emphatic about the impossibility of visually conveying anything 'true' about a person, while others seem to be *absolutely* about the painful business of 'becoming,' that sorting-out of self-awareness and one's place in the social fabric of the day.

Captions offer known information; sometimes only the photographer's name or a date is available. During the project's incarnation as an exhibition[2], viewers came forward with new information, and this clarification of the facts for historic images was and continues to be most welcome. One story in particular stands out as being remarkable, but it may be simply an illustration of the problem of hundreds of omissions and incorrectly labelled photographs in all archives. A photograph identified in the main public library records from the 1950s as "*Nuns and Chinese children arrive in Vancouver,*" prompted one of those children, now very much grown, to state her identity and claim that she and others in the photograph were native to the city and not at all "just arrived," as the caption implies. The image, which previously raised more questions than it answered — particularly given what we know about Chinese immigration to Western Canada in the early decades of the century, the racism, and the problematic history of the residential schools which took place — now is enriched by a distinctive, corrected story.

In the end, I conclude that *Facing History* cannot be a portrait of Vancouver, not in the comprehensive way we imagine such a thing. Rather it is a visual cacophony of possibilities, a fulsome beginning hinting variously at the specifics of each unique individual and the complex world of histories and environments which we (as readers) think might have influenced his or her world. It is hoped that these images will offer up the idea of "maybe" and "unless," the latter a word which is "breathed by the hopeful" and might "prise open the crusted world and reveal another plane of being."[3] And most importantly, if we are listening to our own readings of these images, which are coloured overwhelmingly by our personal experience, this assemblage of portraits can inform and illuminate our own very particular stories.

[1] James Agee, *Let Us Now Praise Famous Men* (with Walker Evans), 1939. [2] *Facing History: Portraits from Vancouver,* the 25th anniversary project for Presentation House Gallery, North Vancouver in British Columbia, Canada, September 8 to October 27, 2001. [3] Carol Shields, *Unless,* Random House Canada, 2002.

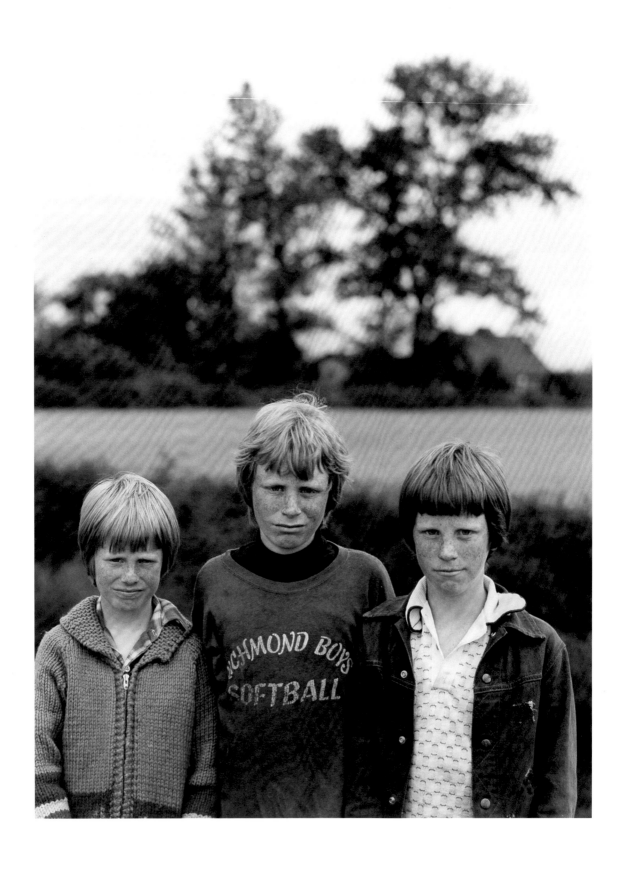

Robert Minden, *Three brothers, Number Two Road*, 1974, from the book *Steveston* by Daphne Marlatt and Robert Minden, Ronsdale Press, 2001 (first published in 1974 by Talonbooks).

Portraits from Vancouver

Shaping Identity

Youth

Art and Life

The Street

Work and Play

Public Life

Mind and Body

```
crown  field  waste  tread  taste
cloud  serve  plant  slide  delay
state  scare  breed  stock  break
force  grasp  share  slice  focus
sleep  visit  crane  float  scale

twist  sight  stake  level  sweat
stamp  light  swing  paper  orbit
tense  party  weave  press  brush
wedge  floor  pleat  wager  flood
print  plate  fling  quilt  chant

trade  lease  drill  nurse  crack
dress  touch  coast  dream  voice
shift  motor  study  steal  order
point  place  leave  tutor  water
value  panic  shape  prize  probe

trick  brand  score  judge  mouth
ditch  grade  sound  crush  layer
truck  limit  spill  pause  braid
catch  storm  stage  blind  close
model  claim  drive  graft  cover

raise  lodge  ferry  stand  guard
stoop  shout  chase  reign  spear
chain  dance  wound  drink  class
fault  watch  feast  court  house
right  smile  fight  trust  grant
```

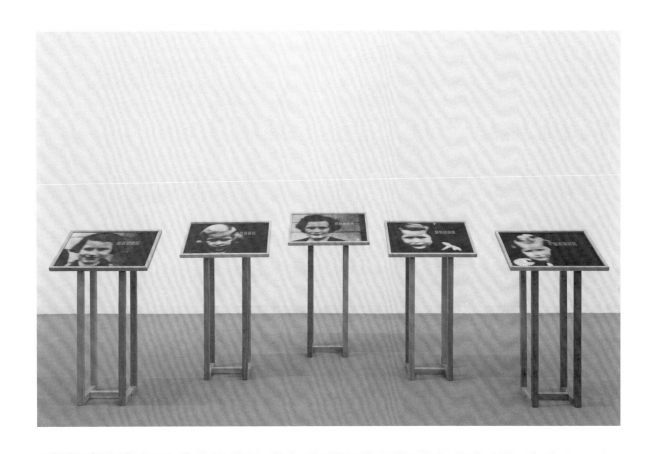

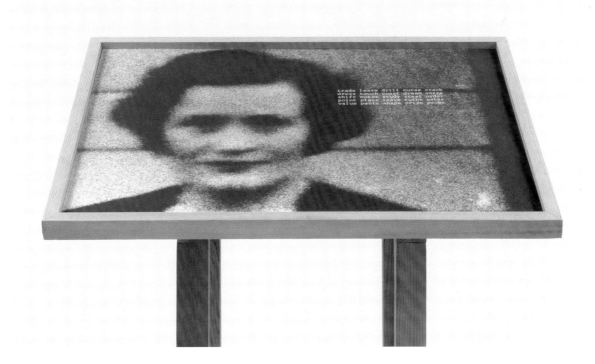

Marian Penner Bancroft, *SHIFT*, 1989, silverprints and paper mounted on 5 cedar stands,
courtesy Vancouver Art Gallery, VAG Acquisition Fund [90.53 a-e] and Catriona Jeffries Gallery.

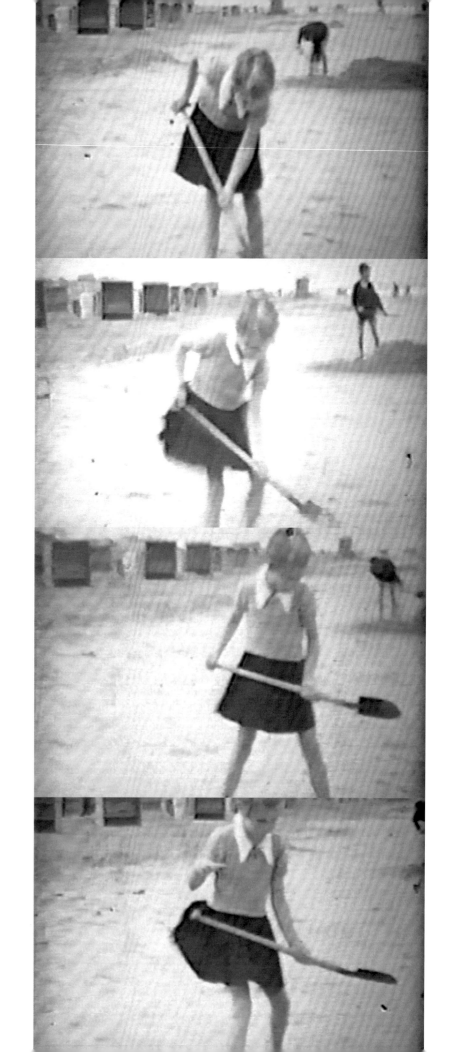

Wendy Oberlander, *Still (Stille)*, 2001 (details), single channel videotape (25 minutes), courtesy Hahn & Daughters Productions.

Delay

Bruce Grenville

There is a child, separated from the others. He has the look, the props, the disposition — but he is too young to belong. There is a necessary delay between being and meaning. And as we strive to give meaning to being, we re-enact that delay again and again. What is the shape and the sound of this delay?

For Jin-me Yoon the delay takes the form of a supplement. An extra portrait of her son Hanum, created during the production of *A Group of Sixty-Seven*. The *Group* is a monumental portrait of a community of Korean Canadians. They are united by a shared history of immigration, a shared sense of loss and displacement. But the portrait of Hanum is not part of the original series. Though it was done at the same time and in the same manner, Hanum does not share the same loss or the same sense of displacement. The portrait of Hanum stays at home, not in the museum with the rest of the group. It is a portrait created in hope and desire. It is the image of a child, *the* child. He is the delay, the one who gives meaning to his mother. Through him she defines her displacement. He is the prerequisite for her existence, just as she is the prerequisite for those who remained in Korea. The identity of the one can only be recorded in the displacement of the next. This is the necessary delay between being and meaning.

In 1998 Wendy Oberlander traveled with her mother to Berlin in search of an originary past. *Still (Stille)* is a story created in pride and desire. Through it she seeks to give meaning not only to her mother's life but also to her own. It is the story of a return to a place and a history that was taken from them. But even before they have left her mother has asked, "Why should I go to Berlin as a Jew if I did not live as a Jew before the war?" And yet they go, knowing they cannot return to an authentic Jewish past because that place and history did not exist. Here we recognize the consistent failure of the past to coincide with itself.

Oberlander's story is told with fragmentary images drawn from an incomplete archive. We are caught up in the silence, we ache for meaning, we surrender to the paradox. "What is this hum?" Oberlander asks. "A sound of memory, the distance between my eye and her eye — now closing." That hum? It is the sound of the delay between being and meaning.

There is a blurred and faded image, a splice, an incompleted memory. There is a hum. There is an unofficial portrait at home, there is a delay.

There is meaning in being.

Jin-Me Yoon, *Hanum Yoon-Henderson*, 1996 (diptych), courtesy Catriona Jeffries Gallery. Photo: Trevor Mills.

The Lenticular

Liz Magor

This work is hard to look at. There are two cards, each presenting a pair of portraits which appear to occupy the same position. With a slight movement of the viewer's head one portrait disappears to reveal the other as in some kind of filmic dissolve. These are lenticular cards, using a printing technology that puts two images in one place by way of faceted ridges, a sliver of image clinging to either side of the ridge. With some head-wagging the viewer learns how to effect these dissolves; girl to woman; woman to woman, thus gaining some control over the viewing of the work. But this security is short-lived as the receding portrait doesn't entirely disappear. Instead it remains uncannily present through some other mechanism.

All four figures resemble one another to an extraordinary degree. The persistence of one in the other is vaguely defiant, daring you to identify each as an individual while they are evidently one and the same. For the card with portraits of two women the contest is more critical because the figures are dressed and posed in exactly the same fashion. This is the visual analogy to sensing the existence of kin in your body, when a gesture, an inflection, a gait feels shared, or borrowed from another, most often a parent. The feelings in this event are mixed; surprise, chagrin. Or, loss and longing. In some sense you feel inhabited as your lenticular body holds more than one identity.

This is what makes these cards hard to look at. In a few dozen square inches they encapsulate the impossibility of individuation combined with the inevitability of difference. What more poignant demonstration of family and human relationships. Even while separate, we are part of a unit. In a blink we dissolve from I to we. And back again.

Corrine Corry, *". . . I realized it was not a photograph of me, but of my mother,"* 1987
(diptych), two lenticular cards.

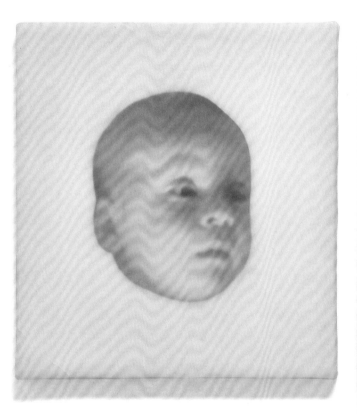

Al Mcwilliams, *I/Me*, 1989, triptych: photography, lead, wax, silver leaf, aluminum,
courtesy Surrey Art Gallery.

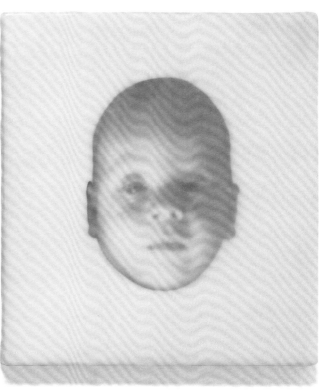

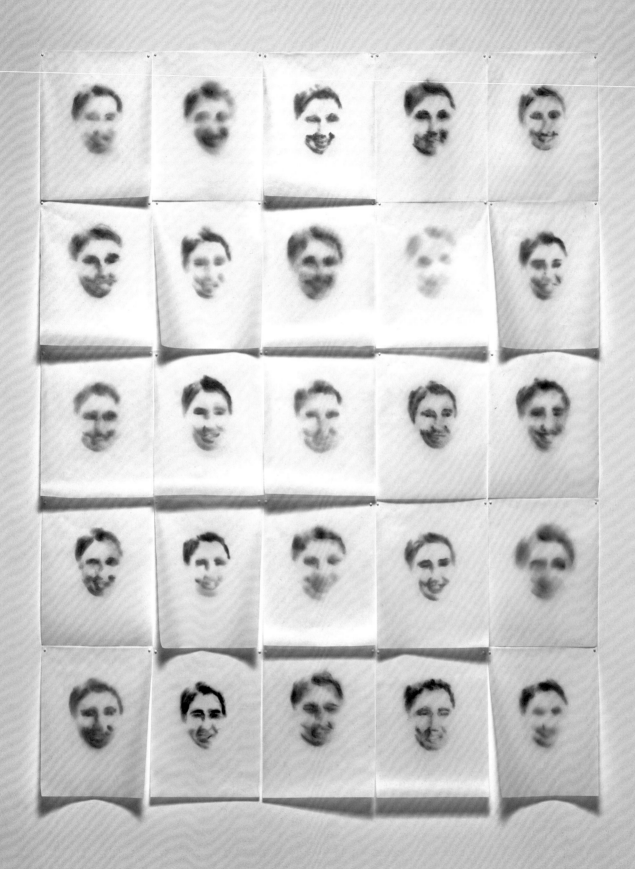

Elizabeth Mackenzie, excerpts from *Reunion*, 2001, graphite on vellum drawings.

Reunion: Restoration

Betsy Warland

Blur of a face — momentary visage of a stranger on a passing bus; smudge of a face — inept rendering on paper. Neither of these signal portraiture in the western world. Yet in *Reunion*, Elizabeth MacKenzie presents us with a series of 25 smudged, blurred portraits of not only the "same" person (her mother), but from the same template (photograph) taken at the age MacKenzie herself is now. Transferred to a slide, she has pulled the focus while projecting the image onto vellum. With the loss of fine detail, she is free to enter this divested face with powder graphite and brushes. In these offspring drawings we see an infant, a businessman, a street person, a self-possessed woman, a ghostly aura, even MacKenzie's own face. All equally real.

The portrait is a mirror in which we seek to recognize ourselves, one another, without effort. Without fear. Portraits defy change. Their faces reside within a hermetic, eternal time, regardless of historical tags of costume, grooming styles and setting. Yet, in face theory, representation reveals that the more articulate the face, the less we imaginatively interact and identify with it. This suggests that underlying our penchant for reality-based representation is an instinct for mobility. For a fixed face (in the flesh) is a dead face.

Is there any other face that we study as intently than our mothers? Our focus range in infancy is 7–10 inches, thus this face maps all other faces; it is our training ground for seeing. Does any other face, by necessity and intense proximity, disclose its inherent "cast of thousands?" Do we ever read the nuances of another's face as proficiently? Ruthlessly? Endlessly? *Reunion* can also reference the pupil of an eye. "Pupil, pupilla, 'little orphan girl,' the miniature reflection of oneself seen by looking closely at another's eye." By locating portraiture via abstraction in this deeply ambiguous, inter-dependant site, MacKenzie has possibly redefined the genre by re-storing lived experience and re-storying the mutability of the prototype face.

The photograph was taken shortly after her father's sudden death. She was fifteen at the time: became an adult overnight. There may be no total body experience as intense and unrelenting as grief. Grief radically alters our sense of boundaries: "we walk around in a daze," "a blur," are forced to see sides of ourselves and one another that are almost unrecognizable.

Elizabeth MacKenzie considers *Reunion* to be "a conversation, commune," a kind of interactive memorial to her mother who died a decade ago. With her generative, destabilized approach to portraiture, she has opened the form to a greater range of integrity and possibility, restoring the nature and origin of portraiture.

Diane Evans, *Chris*, c. 1980.

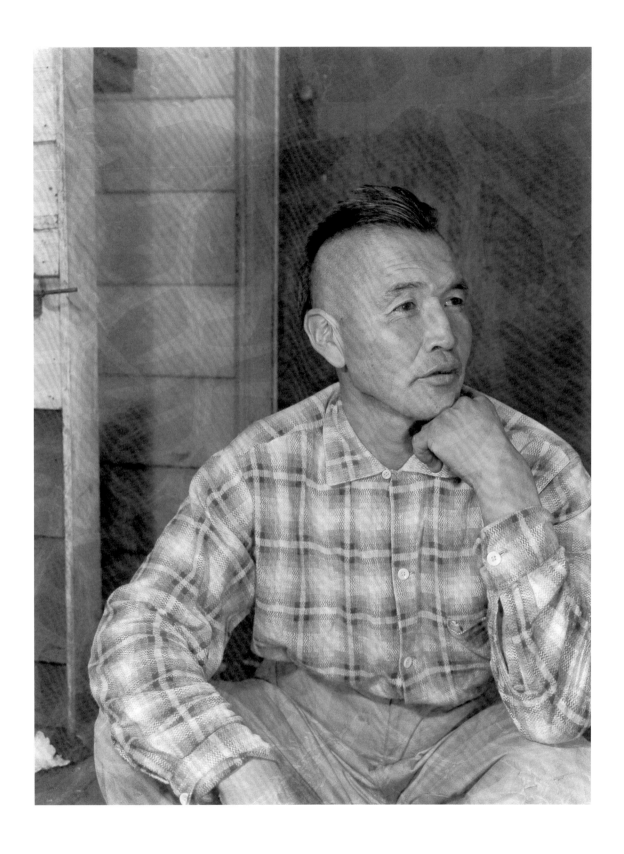

Lee Holt, *Musqeum Indian Reserve, Vancouver*, 1958,
courtesy Vancouver Public Library/Special Collections [1993].

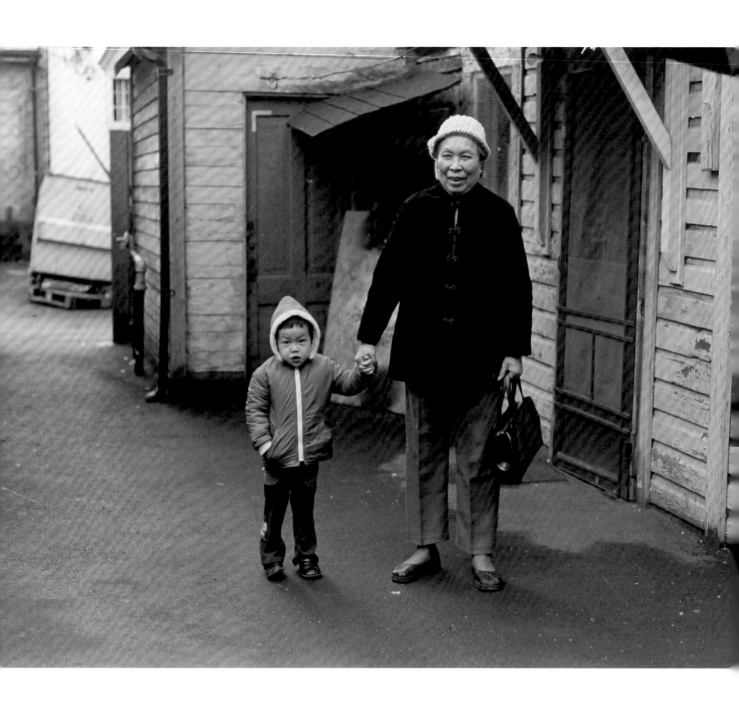

Sharyn Yuen, *340 East Cordova*, 1983.

Untitled

Laiwan

My deep appreciation to Sharyn Yuen for her photographs which inspired this text, written in memory of my grandmother, Yuen Ip Hong (1911–2001).

we know this well, ah paw [1] / images and memories ours and also not /

when you arrived i was three / days sewing in the Hong Kong factory replaced with selling tea and bread to locals / on this voyage you brought almond and old wife cakes / tastes now my reminders of you, the old country and playing in the paved courtyard

timeless noisy streets with gates trying to keep us together / living at once with pride and pain, in wealth of imagination and poverty of materials / shared with adaptability, improvisation and ancestral spirit /

i am remembering the courtyard of our store cemented with memories of immigrant struggle / small chicks grew up here, clucking and crowing, as laundry hung out to dry / to one side was a storage room where the workers lived, sleeping on cardboard for beds / cramped in apartheid without home or family

on the other side was a tree that ba [2] had brought from Mozambique many years before / something i imagine to be like a Chinese magnolia with small yellow-white flowers / and scented sweetly with a name i never knew

this magnolia, grappling also with colonial Africa, was caught between pavement and a brick wall / where the courtyard roof of corrugated iron threatened to cut off its leaves / it stood alone in this little rectangle of dirt imagined by ba as a garden from China

beside this tree was another small courtyard where clothes were washed and we bathed / where mum grew her bean sprouts and the stray cats fought territorially for comfort and home

i remember before the bathroom was built how we washed, all us kids, one at a time, in the big metal basin / we were dusty and the pavement made us dustier / and through my eyes, i noticed a solitude, a quietness / a history of my father and grandmother in these cemented courtyards /

a depth of silence, something like survival /

we know this well / making do with what is left or what is allotted: improvise and adapt, play where you can / this defiance, this insistence to be practical and bear quietly / pursued as an epistemology of our ancestors /

who has shown us to reconstruct this village in the back street?
on this road less travelled, a corner we claim in a humble happiness of basic necessity / versed in cultural adaptation, morphing signs no longer authentic / smiling at survival, proud at the ¹ ability to make do with little /

arms crossed holding the chest together
bands across your cardigan also to keep it together, to keep heart from spilling
hands hidden to keep from telling too much, from having to deny having done anything

these three muses: past, present, future / we know them well
the looking-back-just-in-case, the anxiety-of-where-we-may-fail or for-what's-about-to-come
and then he, defiant and straightforward. eyes ablaze /

we will find you being threatened to change and move / relinquished as tastefulness erases your epistemology

yet every back street fertile the world over and every paved courtyard savoured for its reverie of possibilities finds a magnolia growing today even in a rectangle of dirt /

This is a third installment in a series of writing first published in *West Coast Line*: #32–34/3, Spring 2001. The second installment can be found in *Mix* Magazine, vol. 27, no. 2, Fall 2001.

¹ granny ² my father

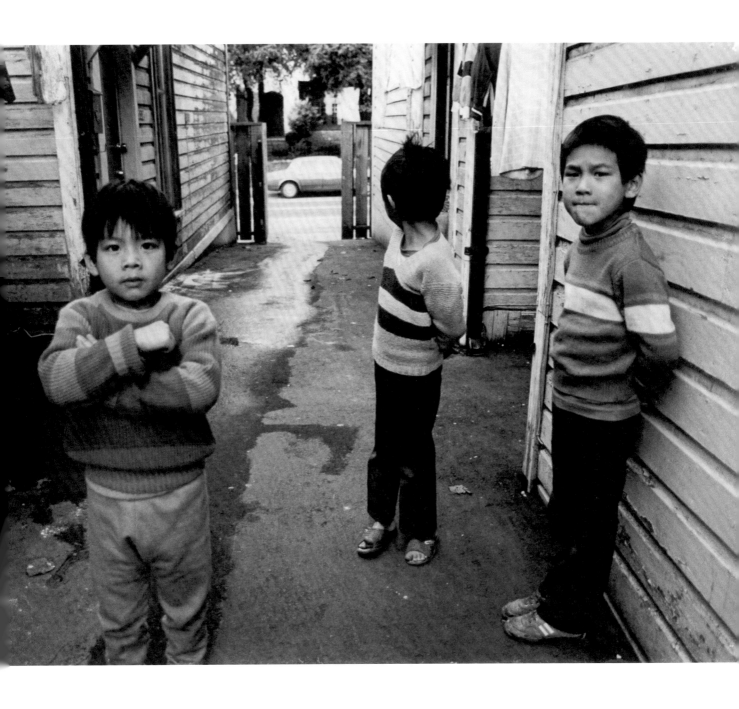

Sharyn Yuen, *340 East Cordova*, 1983.

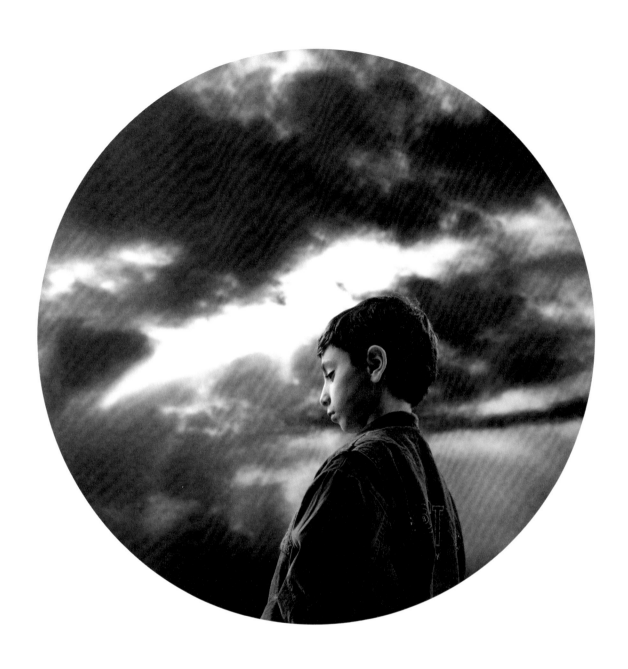

Jeff Wall, *Little Children*, 1988–89, two colour transparencies in light boxes, from a series of nine, part of *The Children's Pavilion*, a work by Jeff Wall and Dan Graham, 1989.

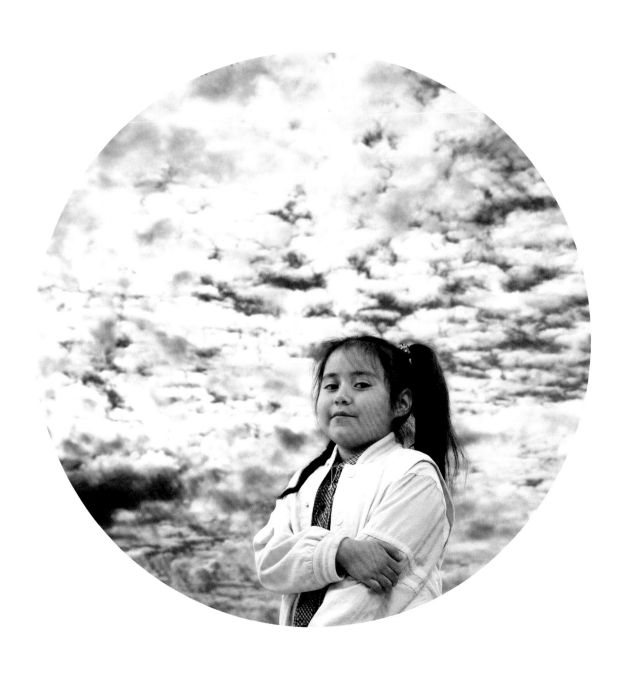

Kyla Mallett, from *Legendary Teens* series, 1999. Top: *Joon Aconley*. Bottom: *Andrew Turner*.

(3)

1. Name: JOON ACONLEY

2. Grade/Age: 12 / AGE 17

3. If you could be any age forever, what would it be and why?
THIS AGE BIC IT'S FUN AND
NO WORRIES

4. Favourite school subject:
ENGLISH

5. Do you have any post-secondary/career plans?
TO EXPAND + CONTINUE MY EDUCATION BY
GOING TO POST SEC. (UBC OR U.VIC)

6. Do you have a job? If so, where is it?
I WORK AT RED'S RESTAURANT IN TSAWWASSEN.

7. What do your parents do? Are they together?
MY MOM IS A NURSE AND DAD IS A DOCTOR.
YES, THEY ARE TOGETHER.

8. Favourite type of music / favourite band or musical artist:
- HIP HOP / RAP - SARAH McLACHLIN
- ALTERNATIVE

9. Favourite artist:
- SARAH McLACHLIN

10. Favourite author/novel:
- JANE AUSTIN

11. Favourite cereal:
- CORN POPS

12. Favourite film:
- CRUEL INTENTIONS.

13. Favourite T.V. show:
- FRIENDS / FELICITY

14. If you could be any celebrity, who would it be?
- JENNIFER LOVE HEWITT

15. If you could date any celebrity, who would it be?
- RYAN PHILLIPE

16. Do you have any idols?

17. Where in Tsawwassen do you hang out?
- OTHER PEOPLE'S HOUSES,
- 7-ELEVEN

18. What do you do on weekends? After school?
- DRINK
- GO FOR COFFEE
- HANG OUT W/ MY FRIENDS,

19. How often do you go into Vancouver? What do you do there?
- DEPENDS ON THE WEATHER
- PROBABLY 4 TIMES/MONTH

20. How do you feel about Tsawwassen?
- I THINK IT NEEDS MORE ACTIVITIES
FOR TEENAGERS W/OUT GETTING IN
TROUBLE FROM COPS/PARENTS.

21. If you could live in any time period, when would it be and why?
NOW, ESPECIALLY W/ THE NEW MILLENIELUM COMING

22. If you could live anywhere, where would it be and why?
A DEVELOPED COUNTRY

23. What do you spend your money on?
- CLOTHES
- GOING OUT (MOVIES, DRINKING ETC)
- FOOD

24. What drugs do most teenagers do (other than pot)?

25. Do you go to Church? Are you religious (if so, what religion)?
NO, YET I DO BELIEVE IN SOME OF CHRISTIANITY

26. What do you think are some important current political issues?
I DON'T REALLY KEEP UP TO DATE ON THOSE THINGS.
HOWEVER I BELIEVE THE BILL + MONICA ISSUE GO
WAY OUT OF HAND.

27. Do you believe racism is still an issue?
YES, PEOPLE SHOULD BE TREATING EQUALLY

28. Do you believe sexism is still an issue?
I THINK IT HAS BEEN BETTER YET STILL CAUSES
CONFLICTS.

29. Do you think advertising effects you? Explain.
YES, YOU DON'T EVEN REALIZE IT
BUT W/ TV ADS + MAGAZINES.

30. What do you think the key to success is?
ATTITUDE TO BELIEVE IN WHO YOU ARE.

(44)

1. Name: Andrew Turner

2. Grade/Age: 16ade 16 age

3. If you could be any age forever, what would it be and why?
14 teen

4. Favourite school subject: Science

5. Do you have any post-secondary/career plans?
yes university

6. Do you have a job? If so, where is it?
yes garden services Tws.

7. What do your parents do? Are they together?
father engineer Yes
mother - print bus.

8. Favourite type of music / favourite band or musical artist:
Punk SNFU.

9. Favourite artist: Lauren Harris

10. Favourite author/novel: Terry Brooks

11. Favourite cereal: Raisin Bran

12. Favourite film:

13. Favourite T.V. show: X-Games

14. If you could be any celebrity, who would it be?
Ramone

15. If you could date any celebrity, who would it be?

16. Do you have any idols?
Grand Father

17. Where in Tsawwassen do you hang out?
every were

18. What do you do on weekends? After school?
Party Skateboard work
Gym snowboard

19. How often do you go into Vancouver? What do you do there?
3 times a month shop
 skate

20. How do you feel about Tsawwassen?
Not enough to do.

21. If you could live in any time period, when would it be and why?
Now, new age cars.

22. If you could live anywhere, where would it be and why?
Edmonton No Pst
lots of snow

23. What do you spend your money on?
Clothes
Food

24. What drugs do most teenagers do (other than pot)?
Extacy mushrooms Acid PCP

25. Do you go to Church? Are you religious (if so, what religion)?
No Yes Anglican

26. What do you think are some important current political issues?
Yugoslovian bombing

27. Do you believe racism is still an issue?
No

28. Do you believe sexism is still an issue?
Yes

29. Do you think advertising effects you? Explain.
No It just there to waste time

30. What do you think the key to success is?
Work hard, stay on task
enjoy work

37

Historical fictions, or when is an arrival not an arrival?

Rita Wong

Although the initial caption declares "Nuns and Chinese children arrive in Vancouver, 1952," five of these seven girls were born on Coast Salish land, in the white-settler colony also known as Canada, and two, although born in China, had already been living in Canada at the time the photograph was taken. I had the good fortune of talking with one of the seven girls who happened to see this image in the newspaper in 2001 and who was very surprised to see her Canadian-born self described as "arriving" in this photograph, almost fifty years after it was taken. Accompanied by the nuns, these seven students at St. Francis Xavier were heading to dance or sing somewhere, not arriving here from exotic lands by boat as the caption implies.

Funny how one kind of performance can so easily become another. Misrecognitions hover in the background:

Boat. The Komagata Maru in 1914; some of the people to whom Canada refused entry were later gunned down and murdered by the British. *Person of colour*. The portrayal of Chinese Canadians as "foreign students" who were "taking over" Canadian universities in a 1979 episode of CTV's *W5* entitled "Campus Giveaway." Out of the protests against the inaccuracies and the racist overtones of the program grew the CCNC (Chinese Canadian National Council) in 1980. *Boat*. Fujianese people dehumanized and criminalized by the media in 1999, their efforts at survival disregarded and mostly met with imprisonment and forcible deportations. *Person of colour*. The still recurring "where do you come from?"

And on it goes.

What does it do to a psyche to be constantly ejected, outed? What burden of representation gets pushed onto you in strangers' thoughtless questions, small human errors magnified by institutions? Doubled, tripled jeopardies. Between the distortions of Hollywood and McCarthyist paranoia, a raced silence into which a girl could sink or swim. Leaving behind a ship of fools. Witch will she be? The girl in the trench coat, secret Asian, her skeptical look, like: *now what is 'history' making up about me?* From perpetual immigrant to global village, the persistent spectre of redistributing wealth haunts one girl's averted gaze.

The chain of misidentifications can be deadly. Just ask the restless ghost of Fred Quilt, killed by RCMP violence in Williams Lake in 1971. Or the ghosts of murdered native women in Vancouver's downtown eastside, not far from Strathcona where these seven girls once lived.

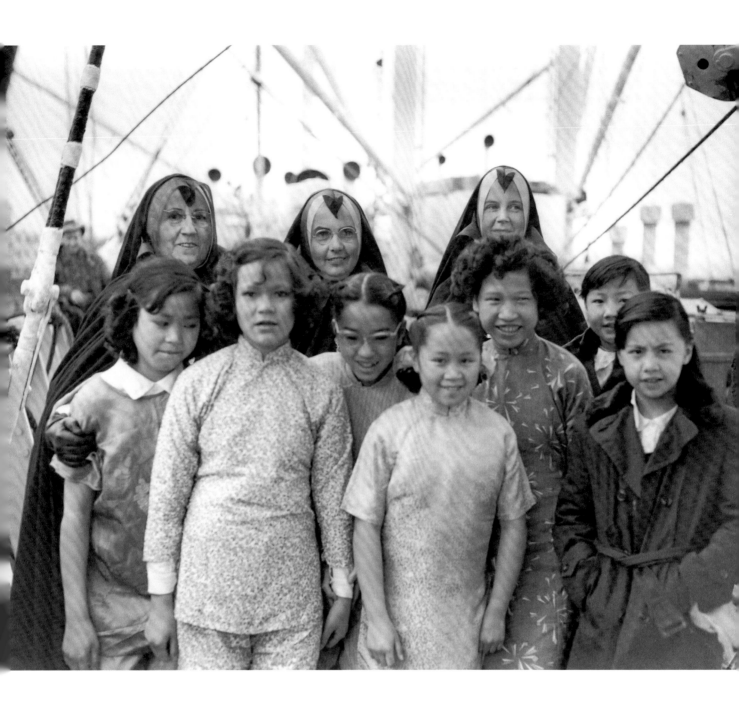

Art Jones/Artray, *Nuns and Chinese children in Vancouver* (archived as *Nuns and Chinese children arrive in Vancouver*), 1952, courtesy Vancouver Public Library/Special Collections [82051-E].

Think of your worst nightmare on a ship
ship and that's where you've ... Aboard
the buses they ... ce gruel and w
chicken broth ... as prescribed
a Health Canad... r w... warned of
not to g... o rich for
stom **JIG-A-BOO**

Class of 2000 / I am a refugee

Paul Wong

Featuring: Jackie in Jig-A-Boo / Chad in White Trash / Jason in Chink

The three panels of this image are reconstructed frames from I AM A REFUGEE, part of a series of television spots created for the *Unite Against Racism* campaign 2000. The television ads commissioned by the Canadian Race Relations Foundation were broadcast on national and regional networks and used as part of educational materials in schools across the country.

The subjects are members of the Class of 2000 from Sir Charles Tupper Secondary in Vancouver. Tupper was chosen because it was the school that I attended in the early 1970s. It is an inner city school that reflects the cultural diversity of Vancouver, and is also a school attended by many new immigrants — the students reflect the hopes and dreams of their parents who have come to this promised land of equal opportunity. The Class of 2000 is the generation that straddles the past, the twentieth century of hate and violence, and the future, the 21st century of new possibilities.

Paul Wong, *Class of 2000 | I am a refugee*, 2001.

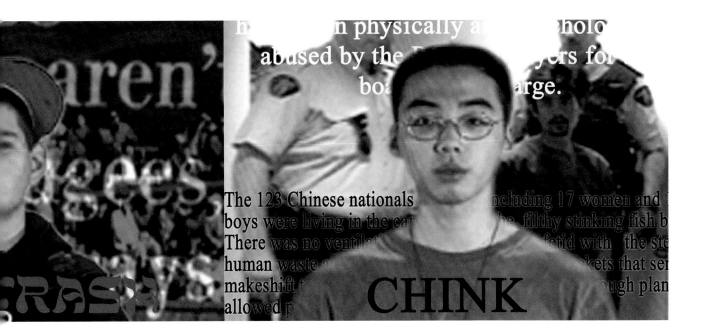

Paul Wong's image was commissioned for one of five billboards produced by Presentation House Gallery for the Facing History Poster Project in Vancouver. In August 2001, the company that manages advertising space at the Seabus Terminal, Obie Media, informed us that they were worried about possible negative responses to this poster and would therefore have to forward it to Translink for assessment and approval. The Gallery negotiated on a daily basis with both parties, arguing the image's merits and the right of the public to come to their own conclusions about the work. The story was reported in an editorial on issues related to the presentation of difficult ideas in the public realm (Vancouver Sun, September 8), and all involved were commended for their persistence in trying the resolve the matter. All parties, including Paul Wong, had agreed to the application of an adjacent panel for the poster: a text advising viewers how to contact the C.R.R.F. if they wished to help with the Unite Against Racism campaign. We made it clear that we were available to any transit employee or member of the public who wanted to discuss the project, and the artist undertook a number of media interviews. However, production difficulties and additional approval phases caused further delays. A subsequent meeting of all parties resulted in Translink inviting responses to the image from Seabus Terminal employees. Eventually the poster was installed when it was determined that there was no reason for refusing it. It appeared at the Seabus (South) Terminal for a few weeks during late October / early November, after the exhibition had closed. Neither the artist nor the Gallery received complaints. We are told that the average weekly ridership on the Seabus is 115,000 people.

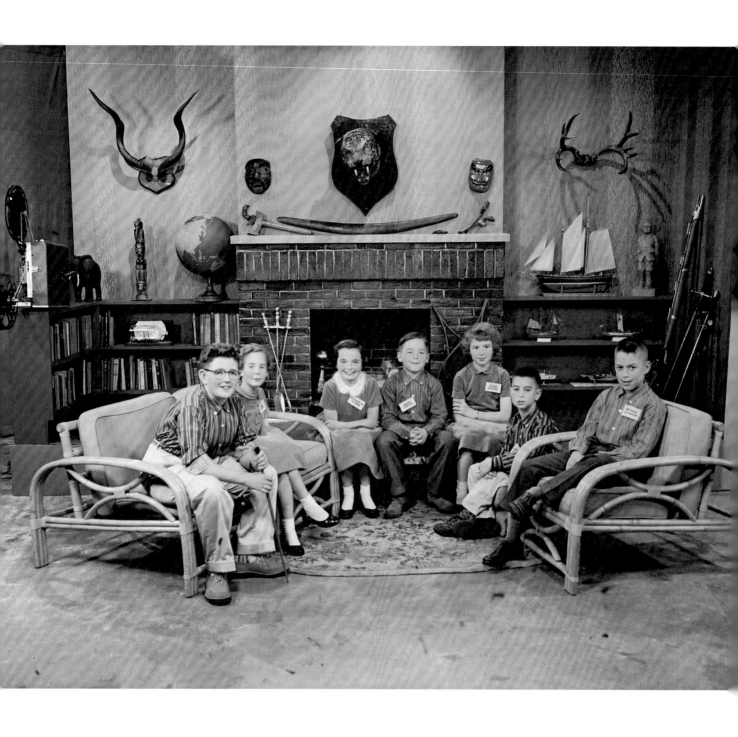

Alvin Armstrong, *Barney's Gang*, April 24, 1958 (with emcee Barney Potts, not pictured),
production still, courtesy CBC Vancouver.

Youth

TV Time

Richard Rhodes

Most photographs stay private: kept in albums and scrapbooks and dresser drawers by the amateurs who take the pictures — usually of family and friends — and then develop their film at the mall. The other images, the ones in public domain, find their visibility in art and commerce. Fine art photography is now ensconced in the history of art but the commercial zone remains a dark continent still looking for its historians.

The territory is open-ended and vast, with each photograph created by a competent, trained image-maker operating at the point where photography intersects with the practical needs of business. Concerns about the impact of commodity culture on contemporary identity and consciousness have drawn the art world closer to these neglected sources. Product photography especially, with its evolving line of lush objects of desire, has already attracted ironic appreciation.

However, there are other images — more earnest, less facile — that are documentary in mode. We can think of them as the family photos of the business world — the images, often promotional, that have aged quickly, lost their purpose, and been outmoded by changing period styles as the business world has moved on and grown up. Often less accomplished than product or celebrity photography in terms of style and technique, these journeyman images have a softer even banal impact. As the fantasy realm of the commercial retreats, however, the edges of the real creep into these pictures. It is as if in their comparative weakness as images, we can begin to see more clearly the subtle dependencies and shortfalls that accrue between culture and business.

Alvin Armstrong's pictures now seem like finds. Armstrong was a staff photographer for CBC Vancouver in the '50s, '60s and '70s. During that time he worked shooting production stills of in-house programs, which usually ended up in on-air ads or as promotional fodder for weekly television guides. As these immediate needs passed, the CBC filed his prints and over time they built a useful archive of the sets, lighting and casts in the station's programming history.

Their impact now, however, is aside from all that. Now when we look at them, we see photographs that bracket the boom years of television, that reach back into the pulse of their time and culture. The colour image is of *Barney's Gang*, a Vancouver children's show from the late 1950s. In the picture, which holds some of the sweetness of the time, the girls are in

bobby socks, the boys in Hush Puppies. They sit paired off like suburban couples at a party in a basement rec room. The other image, a black and white one from the early 1970s, captures a mid-game moment in the weekly high-school quiz show, *Reach for the Top*. Nothing in either picture is photographically remarkable or original beyond its moment. Armstrong centers his subjects. He shoots them in bright, hot studio light. Focus is full from front to back.

Their attraction is in hindsight, in the coursing, inadvertent, embedded subtexts that undo their simplicity. Look again at *Barney's Gang*. With its trophies, sailboat and swords, the set is couched in a rich set of imperial presumptions and expectations. The décor might have seemed just fun or comfortable in its day but it signals that these kids are playing in what is imagined as a mastered world. They assume adult roles and in watching them look ahead, focused on Armstrong's camera, it is hard not to think of the very different future that the television camera will eventually help bring them. In the second image, we see a bit of this future in fifteen-year-old faces fifteen years later in a modern, brutalist set. It is a place for the quick and knowledgeable where names and numbers register first. Louise Renney has just hit the buzzer. In the terms of the game, she gets to be just right or just wrong. Her look of anxiousness makes it seem part torture and leads us to wonder how Armstrong's camera might show, thirty years later, how the children are doing now.

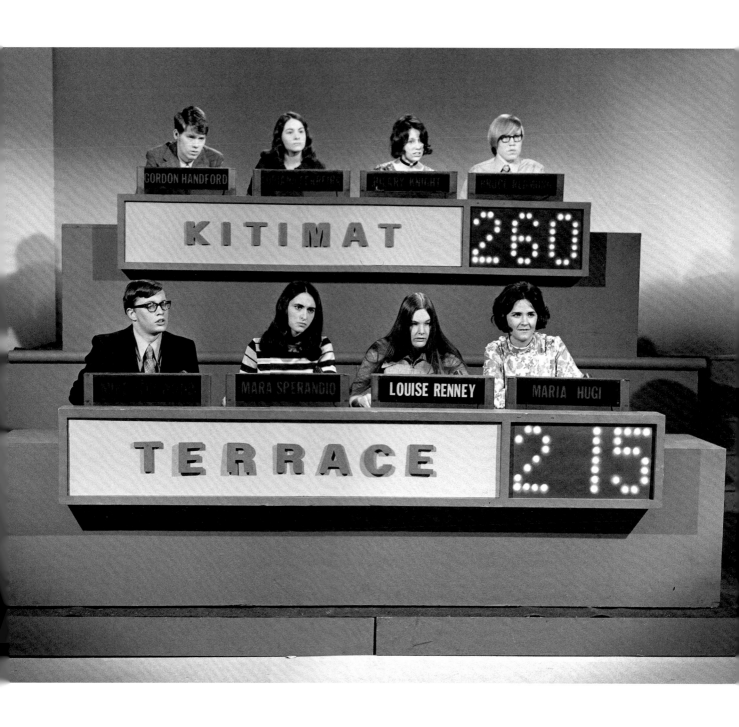

Alvin Armstrong, *Reach for the Top*, March 30, 1971, production still, courtesy CBC Vancouver.

Arnaud Maggs, from *48 Views* series, 1981–83. Clockwise from top left: *Renee van Halm, Marian Penner Bancroft, Ron Thom, Theodore Wan,* courtesy Susan Hobbs Gallery.

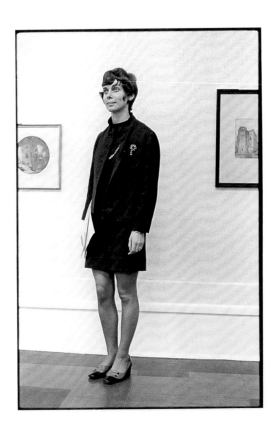
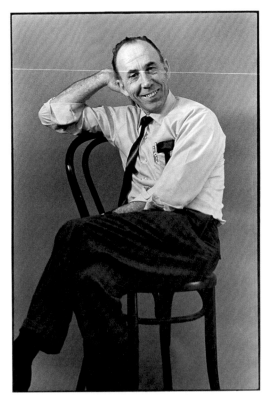

Photographer unknown, *Portraits of VAG staff*, 1969. Clockwise from top left: *Milly McKibbon*,
Art Kilgour, *Shrl. Sanders*, *David Catton*. Courtesy the Vancouver Art Gallery.

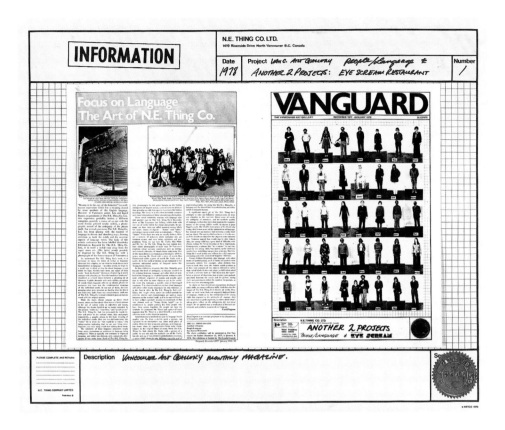

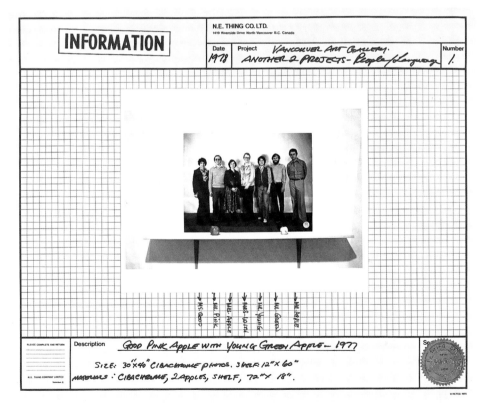

N.E. Thing Co. Ltd., *Vancouver Art Gallery monthly magazine* and *Good Pink Apple with Young Green Apple*, from the project *People/Language*, 1977, which brings together people with surnames that are also common nouns, verbs, and adjectives. Silkscreen prints with collage materials, courtesy Catriona Jeffries Gallery.

Simulation — Self-portrait with abdomen of an ant

Jerry Pethick

In 1988 I completed my first array camera (which captures 99 simultaneous viewpoints of the same scene) using ærial black and white film for the negatives, which were 9" x 14" in size. I made three self-portraits at that time: two with flash and one by a long exposure. *Simulation: Self-portrait with abdomen of an ant* is the second flash portrait and it was with this exposure that I discovered an ant had found its way into the camera; the abdomen of the ant is apparent in the image, slightly behind the simulated coloured reconstruction, drawn there in crayon.

The actual reconstruction seemed too ghost-like to form a discernible dimensional illusion, so I drew how I imagined the formation of the array portrait would appear. The spectra foil rectangles represent a vision of the psychic scars that seem to exist in portraiture and these take the symbolic form of the black tape-like rectangles that disguise the syphilitic skin abscesses included in Hogarth's prints. The marbles from a Chinese Checkers set established the circular shape, like the individual image circle of each exposure behind it and the configuration of the imagined single reconstruction of the multiple portrait.

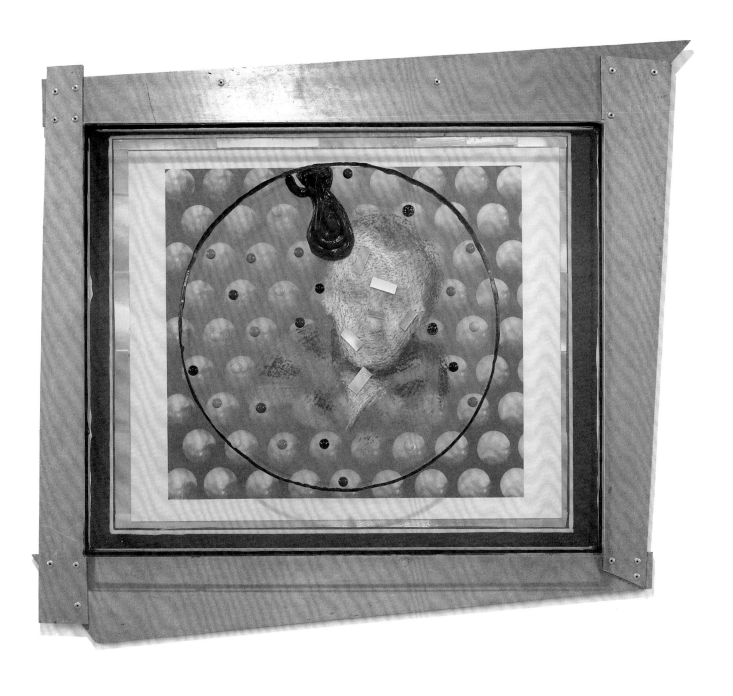

Jerry Pethick, *Simulation — Self-portrait with abdomen of an ant*, 1988,
aluminum plate, pop-rivets, glass, glass marbles, silicone sealant, crayon, array photo, spectra-foil,
courtesy Rojeanne and Jim Allworth and Catriona Jeffries Gallery.

Carol Sawyer, *Fifteen Minutes with Neil Wedman*, 1991, silver gelatin print from pinhole camera negative.

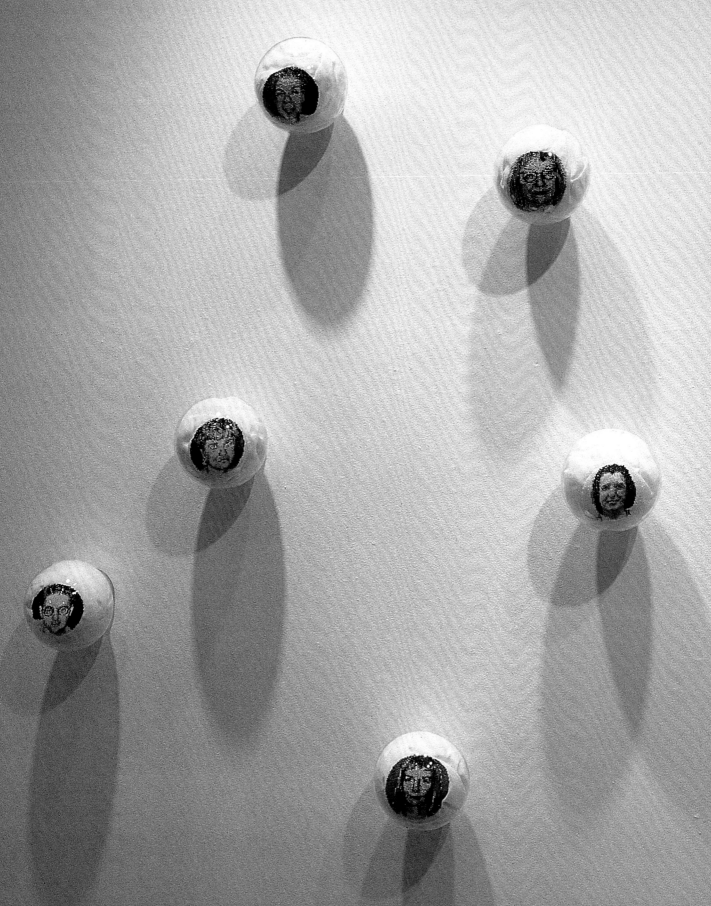

Colette Whiten, from *I Witness*, 1996–1998. Clockwise from top: *Max*, *Renee*, *Liz*, *Karen*, *Kim*, *Marnie*. Glass beads, embroidery cloth, glass, courtesy Susan Hobbs Gallery.

53

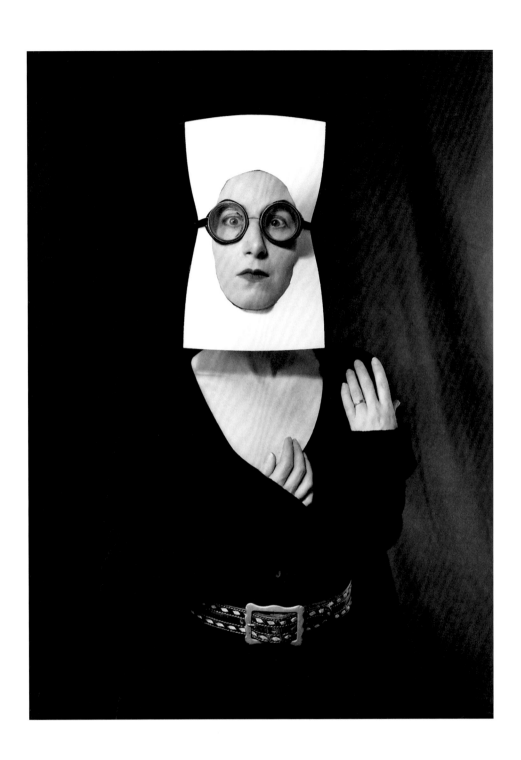

Natalie Brettschneider performs Oval Matt, *circa 1928*, courtesy Carol Sawyer.

Natalie Brettschneider:
a Portrait

Carol Sawyer

During the early part of the twentieth century European composers, musicians, dancers, painters, poets, actors, and choreographers collaborated to create experimental art works that stretched the boundaries of existing genres. In the meagre documentation of performance activity that has survived, one name comes up repeatedly: Natalie Brettschneider.

Brettschneider was born in New Westminster, B.C. in 1896. A precocious singing talent with a voice of unusual beauty, in 1913 she won a scholarship to study in Paris with the renowned vocal pedagogue Mathilde Marchesi. As a provision of her scholarship, she presented product demonstrations of antiseptic throat gargle every Saturday afternoon in the basement of the Samaritaine department store.[1] These events soon attracted a cult following among the Parisian avant-garde, many of whom became life-long friends and collaborators. Brettschneider's work was usually ephemeral and site specific. She considered virtually everything she did to be part of her art practice, and this contributed to her unusual eclecticism. Her three-month-long marathon performance *Flannel Flaneuse* consisted of a systematic walking tour of each *arrondissement* of Paris. Her piece *Oval Mat* contained a monologue of veiled caustic commentary on the sexism of certain members of the surrealist movement. She considered the living muse / genius relationship parasitic, and insisted on being recognized as the author of her own image and actions.

During the Second World War she returned to the United States, where for ten years she pursued a career as a jazz singer. In the 1950s she was blacklisted as a suspected communist sympathizer and fled to Canada. Her last years were spent in Point Roberts, Washington, where she hosted small soirées at the local community hall. She died in 1986.

It is unfortunate that more is not known about the pioneering work of artists like Natalie Brettschneider. Few historians have expected to discover female artists of her calibre, and that lack of expectation has blinded scholars to the significant contributions that women made to the avant garde of the last century. Natalie Brettschneider has taught me that all history is to some extent a portrait of the author: a largely fictional narrative molded by the interests and prejudices of the writer.

[1] The author is grateful to Andreas Kahre for bringing these performances to her attention.

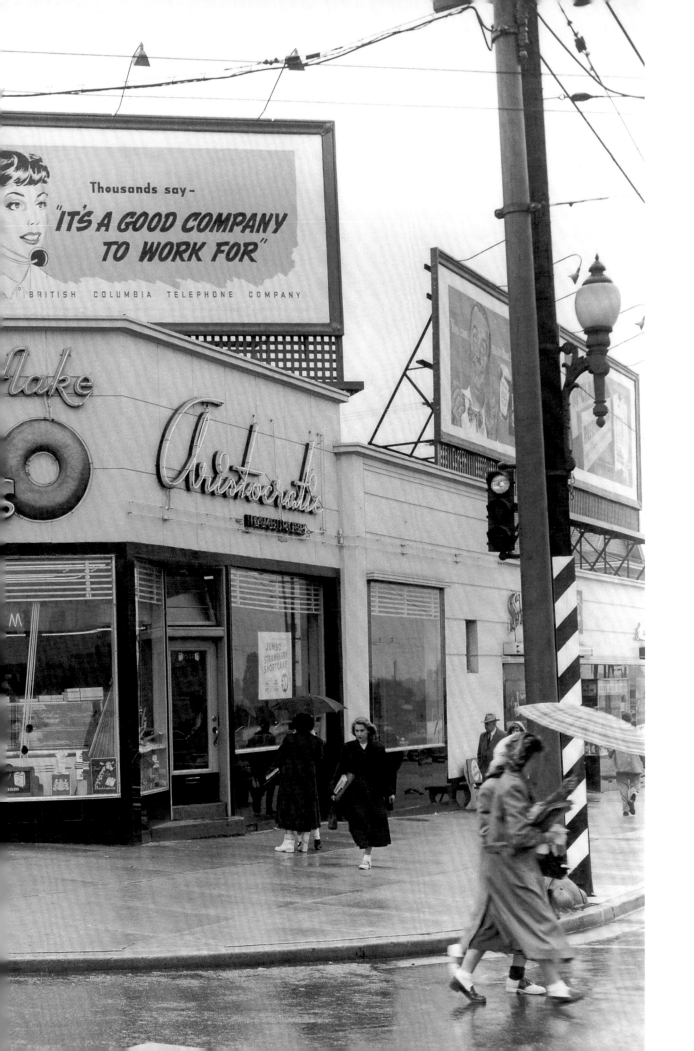

Ian Wallace, *My Heroes in the Street VII*, 1987–2001, C-print and canvas on paper, courtesy Catriona Jeffries Gallery.

Ian Wallace, *My Heroes in the Street IX*, 1987–2001, C-print and canvas on paper, courtesy Dale Steele.

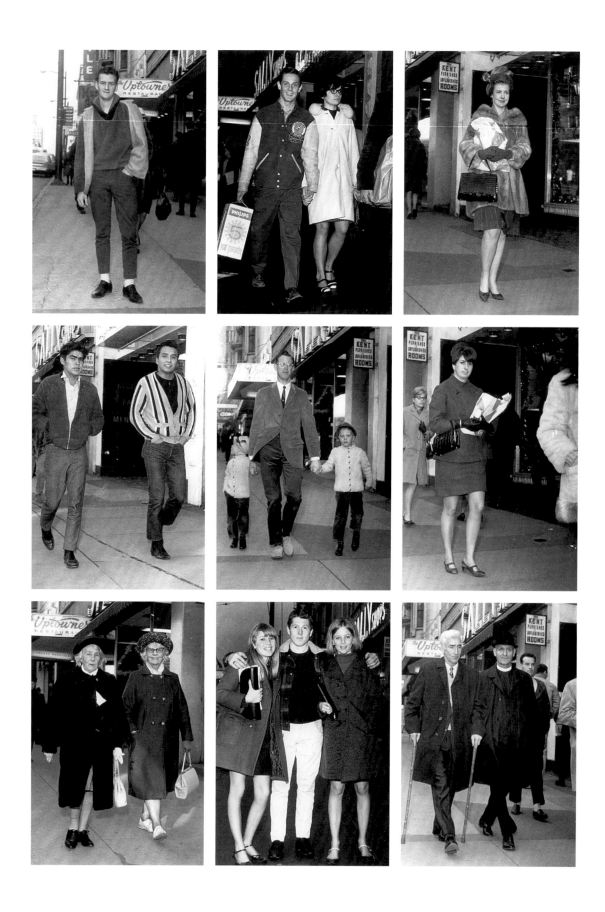

Foncie Pulice, Untitled, 1946–1979, street portraits taken with a camera
made from war surplus material and powered by a car battery.

Traffic Patterns: 1946–1979

Helga Pakasaar

On reels of negative film wait over 20 million human stories. A corner facing Granville Street in downtown Vancouver served as the stage for this registry of portraits by street photographer Foncie Pulice. A backdrop of signs for the Uptowne Restaurant, Sally Shops and Kent Rooms establishes time and place, yielding clues to the particularities of the city. I scrutinize the snapshot of a sixties dad steering his two boys along the sidewalk. Though caught off guard, they are on a public outing and thus fully outfitted for social scrutiny. Dad feels sharp in those cords and Hush Puppies as long as he still has the security of white-shirt-and-tie maturity. The boys, dressed in identical "little man" suits from Simpson-Sears, complete with Tyrolean caps, are absorbed in their private distractions, as yet oblivious to the grasp of paternal will. Yet already Garth's sullen obedience and Gary's self-absorption reveal differences that eventually pulled the family apart. She found the card in his pocket and ordered the photo from Foncie's wife, the small size, to tuck away for herself. In that memento was the promise of survival and it's still there, somewhere.

But only those who can name and remember the particular can breathe that kind of life into a Foncie portrait. As keepsakes they are absorbed into evolving personal narratives, but as isolated images they do not speak for themselves. Only as a collection does Foncie's blizzard of portraits begin to make sense. Anonymous, free of artiness, the very generic nature of the snapshots inspires the impulse to organize them into patterns of the social collective. Aside from a soft spot for dames, Foncie's process was by necessity democratic — anyone walking by was a potential customer. Unlike studio portraits that declare formal relationships in every considered detail, such casual street encounters allow for improvised personas. Families, friends, first dates, and shoppers cluster in front of the contraption pressing against one another, strike a pose, disentangle and then carry on, usually with no intention of seeing the results. Then there are those who just keep walking, thinking it's not a time to remember, or resenting the Electric Photo man's surveillance. Regardless, Foncie systematically pressed the shutter.

Compelled to make sense of these disparate lives spliced together by chance, we try to compare, categorize and index them to map a social fabric. Yet the patterns shift as new stories emerge. Involuntarily, our eyes are arrested by the punctum of details. We scan faces for signs of true happiness and mental disturbance alike. Each person projects multiple

selves—some possible, others imagined—and unconscious gestures seem pervaded by communal attitudes. The street is a civic space where public and private identities intersect, where reverie and conscious behaviour feed one another. In the end, it is the vernacular idiosyncrasies of Vancouver's social history that surface and cohere into distilled narratives. Foncie's mechanistic and dispassionate process reveals the textures and eccentricities of the mundane, providing clues to the secrets in everyday lives. It is precisely the traffic of incidental detail reflected in this photographer's indifferent gaze that keeps us looking.

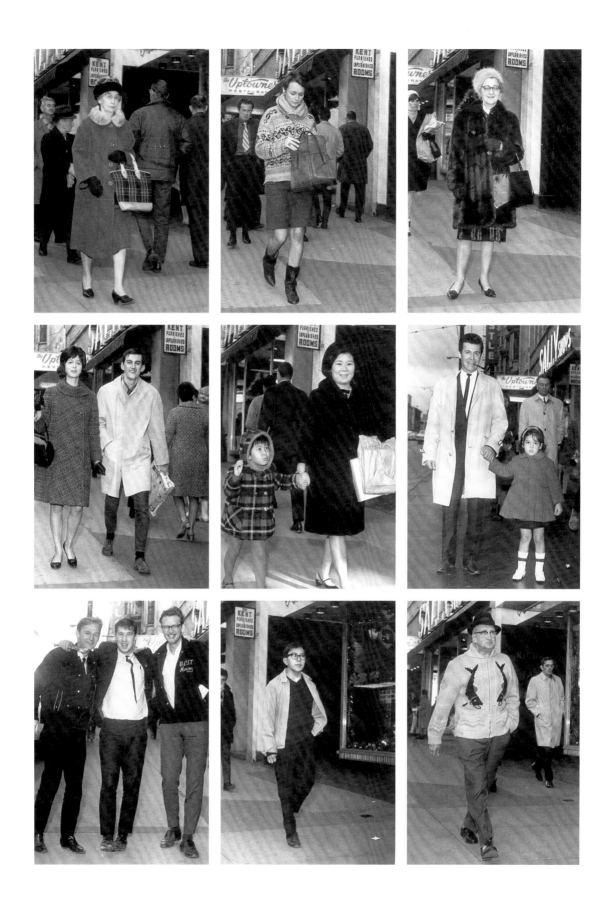

Foncie Pulice, Untitled, 1946–1979.

Michèle Smith, *"George Smart, A Friend to the Library"*
(diptych), from the *Memorial Bench* series, 2001.

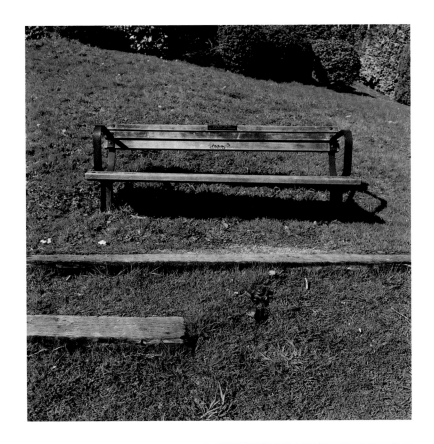

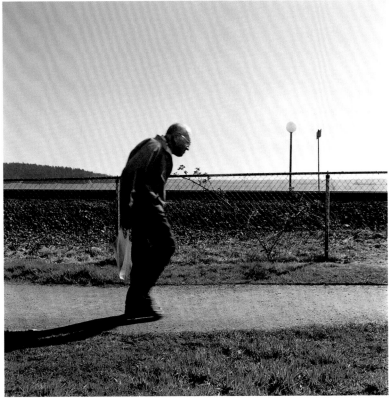

Michèle Smith, *"How sweet the sunlight rests upon this bank. Here will we sit"*
(diptych), from the *Memorial Bench* series, 2001.

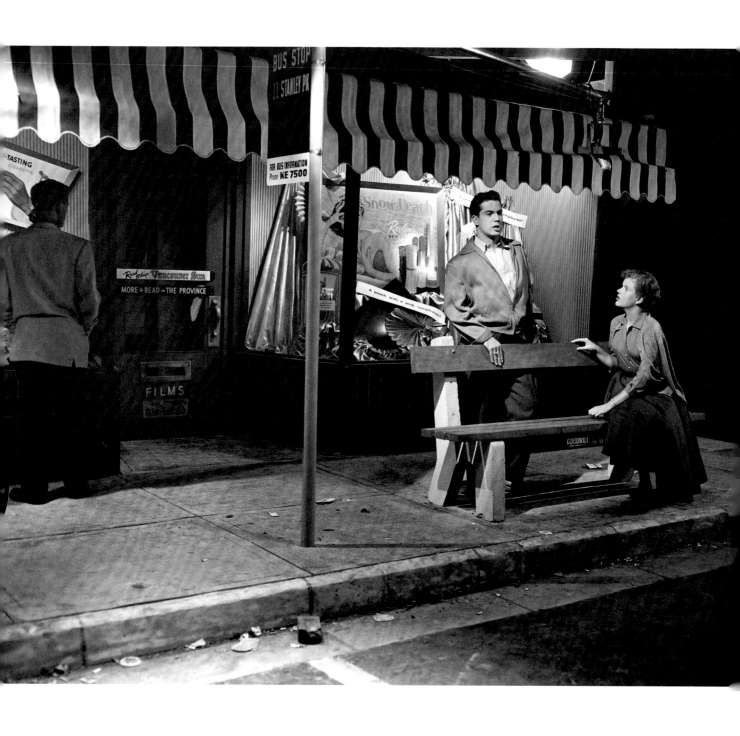

Alvin Armstrong, *An Aspect of Crime*, July 30, 1956, episode from the series *Pacific 13*,
production still, courtesy CBC Vancouver.

An Aspect of Crime
(An Alphabetical Acrostic)

Colin Browne

Although it can't be, it could be; each grain's carefully stroked
into place to deflect evidence of spontaneity, to fend off the gloat
that hovers around irony, for the job's too often a kiss-o-gram,
a low-rent mimetic let-down, so I note the object is a pose, a
sentence drawn-and-quartered to reveal a triangulation project-
ing signs onto a sacramental terrain where unspoken violations
and a world-shaping indexicality reprise a youthful sextet of
zygomatic arches, a broadcast called *An Aspect of Crime*, the devo-
tional ecstasies of Faust and the little Armageddon that grips
the photographic act—a heliotropic dodge—for this is jour-
ney's end, these lovers won't kiss again, in a flash Light will be
murdered by Darkness with its nimble occlusions, portrayed
here by one who quietly rotates his rump our way, the sinister
Gentleman, taking all the time in the world under the banner of
BEST-TASTING, and, violently lit on the far right, she who'll sacri-
fice all for her xenolithic darlin', yielding to his zealotry though
she anchors a bench called GOODWILL, for the beloved chafes
at the evening air and, fattened by her greedy love, swells into a
monster of conceit, a harbinger of self-abstraction, ignorant of the
jeopardy he's in, a Knight of Delusion on the Night of Reckoning,
convinced the lustre's his, that the melody he hears is the Nile of
his own blood pounding, and he basks, while in the quiet portal
—where rival emblems simulate the celestial war of Upper and
Lower, where a slot to a vault called FILMS is the wolf at Kodak's
door—the Adversary exhales, relishing the snare, or yawns,
bored with these Zarathustras debating love and freedom as if
they believe conjugacy's probable, as if, dear reader, they believe
they exist as anything but molecular realignment on a Fifties pro-
duction still, but we've gone too far, going home's impossible, for
even the 'Snow Peach' is a cosmic joke, its scent is the kiss of

summer, yet it looms as winter's kin, and the defaced mademoiselle, with her new, Oh, so pink innocence, is queen to columns of phalli; the result's a single frame of a morality play in which the bell's been rung for the unraveling, vertiginous soul of Everyman — the lump of pride will be expelled through his jacket's yawning V — where, in this symbol-swamped *zarzuela*, a hand with a ring (he's whose betrothed?), clutching the dynastic bench, echoes the hand fleeing the Adversary's head, a hand gone to simulation, a manicured hand foretelling the imminent fate of our jawboning Galahad, soon to be kippered in ink, for the Light — the Comforter's mercy and nourishment — will vanish, our lad's blind to the projections on the quivering bench — the concrete riser forms an 'h' and an inverted 'y', the shadows beneath it a 'w', invoking the unutterable Name with its benison — or is it venison he's chasing where the thicket thickens, where his exemplar's yon halved brick, undone by zygotic rivalry, an allegorical hell Armstrong breaches confidently in this image of the damned, a Manichean echogram of charred forests, reliquary tableaux and glinted light, of heavenly interventions that justify these bags of flesh, of kleptomaniac duets with our lost infancies, as if these might attract the notorious attentions of the Other, but "Otherness is death, death is Otherness," so put your heart into the quadrille, we'll refute the subject/object trap, for until there's no Truth or Illusion to vie with we'll only replicate our exemplary woes and yearnings, picking the sovereign zit as if it's a masterpiece; let's declare that the battle is all, and in its consecrating, doomed embrace we'll be made whole, for I see this in Armstrong's photo-gerund, and have an idea that *An Aspect of Crime* might just be the kind of Ur-photo that lined the metaphysical nest of photo-conceptualism in this querulous, uncertain, prolific place.

"Otherness is death. . . ." The line is from Yehuda Amichai's "Names, Names, in Other Days and in Our Time," translated by Chana Bloch and Chana Kronfeld and published in *Open Closed Open* (New York: Harcourt, Inc., 2000).

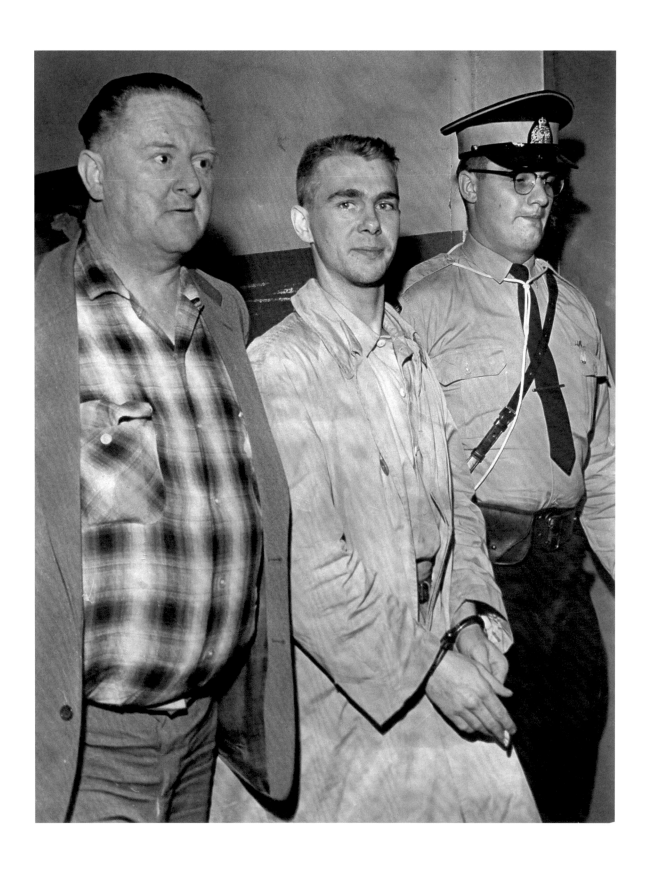

Bill Cunningham/*The Province*, untitled, n.d.,
courtesy Pacific Newspaper Group and the Cunningham family.

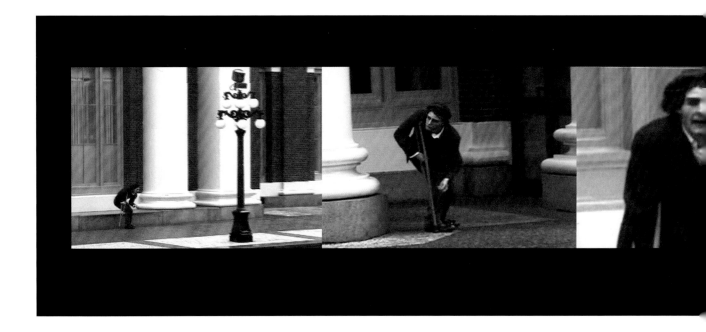

Please

Karen Love

This image sequence by Judy Radul emphasizes one of the ongoing performances of Vancouver street-life, variously described as "spare-changing," "panhandling," or begging. Unlike a documentary photographer, Radul does not assume she can expose real conditions with her camera. Instead she chooses to create a theatricalized image, one which sidesteps naturalism and accentuates the playing of assigned roles.

 The images are specific to the Seabus station (originally built for the Canadian Pacific Railroad) as a public location. They visually pose the question: How does the craving for heritage grandeur interface with contemporary social conditions? The honorific term of "gov'nor" used in the poster points to an older, colonial social order and conventions of address which confirm class. With a nod, a manufactured twinkle of the eye, a please and thankyou — an interchange of enforced joviality also familiar in the broader service industry — social and economic positions are reinforced. The choice of video stills over photographic images makes reference to both tourist video and Hollywood movies. The hard, grainy quality of video distorts and decomposes both past and present.

Judy Radul, *Please*, 2001.

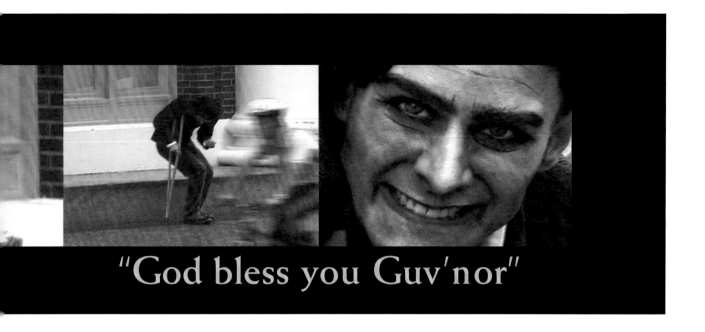

"God bless you Guv'nor"

Judy Radul's image was commissioned for one of five billboards produced by Presentation House Gallery for the Facing History Poster Project. *It appeared at the Seabus Terminal (south building) in Vancouver during the months of September and October 2001.*

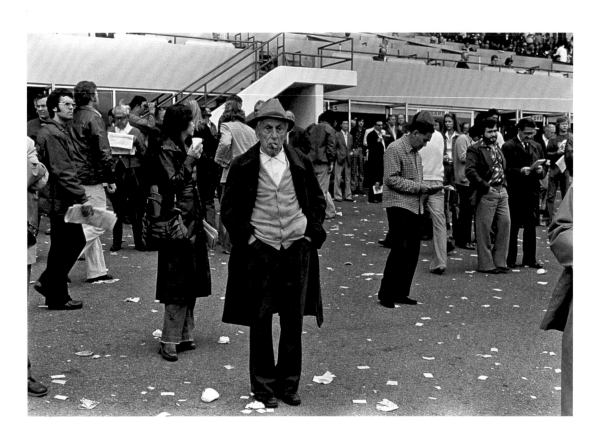

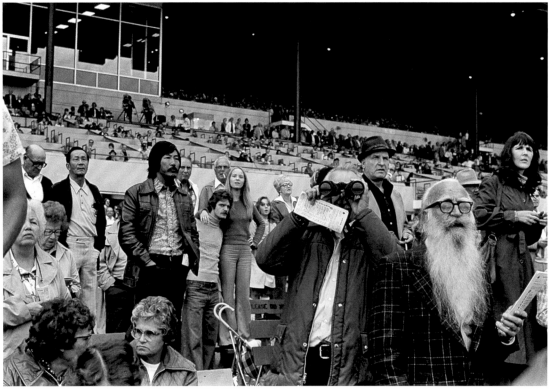

Diane Evans, from the series *Exhibition Park Racetrack*, 1979.

Win, Place, and Show

Russell Keziere

Hope distilled with desire
into common yearning
defines a place.

A salt wet night late
in the thoroughbred season
infuses these punters with
wishful denial of handicaps,
against all odds.
Chits littered underfoot,
the shredded remains
of paper prayer wheels.

The climax hangs in time
perpetually unresolved
 ". . . it's a *photo* . . ."
a photo finish one horse
wins by its nose
not its legs.

Fault lines between
win, place, and show
crack open to reveal a history
built on chance, a boom bust
wheel of occasional fortune
sudden gushes of amazing
disappearing losses and winnings
whether from hewing,
fossicking, or mere
capital influx from one
British property whose
lease has expired

to another
now unable to explain
the sudden waning
of once uncountable fish.

Once there were fish
and that distant north shore of
the inlet was an exotic
minnegrotte of eternal
summers kept for
new youth to practice
their allure on one another
advertise their promise
to all, first this backlit pose
and then another, their
photo finish a
languid beginning,
presumptuous that the tide
would ebb and leave
their table set
again.

Should they abandon
this still lotus moment,
their wager will be
complete — no more
bets, no more bets —
and recross the bridge
from past to present
wearing it down
an incessant commute
and only one lane light
flashing to now allow
us from present
to past.

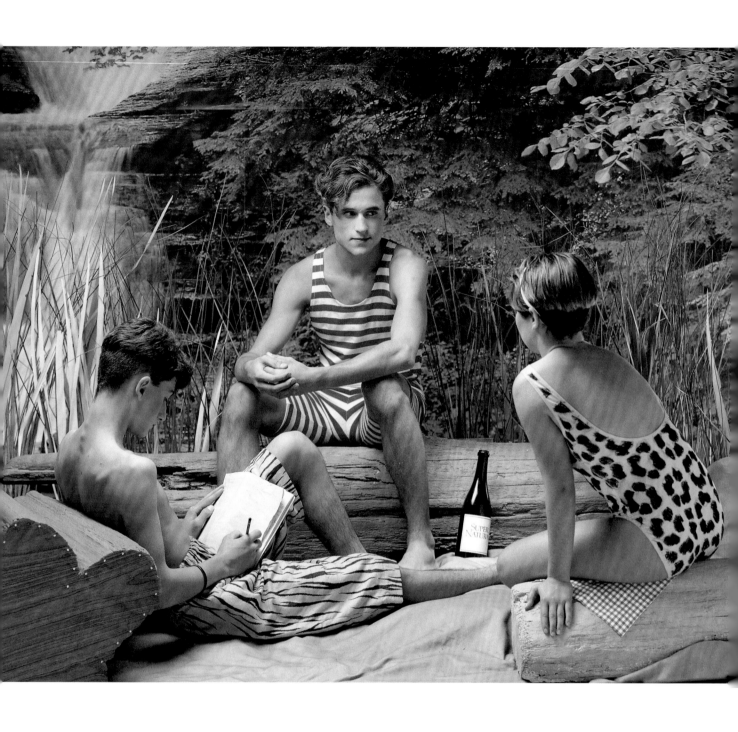

David Buchan, *Canadian Youth*, 1988, courtesy Heather Buchan.
As part of Presentation House Gallery's Facing History Poster Project*, this work was remounted as a billboard image in downtown Vancouver, September/October 2001.*

Work and Play

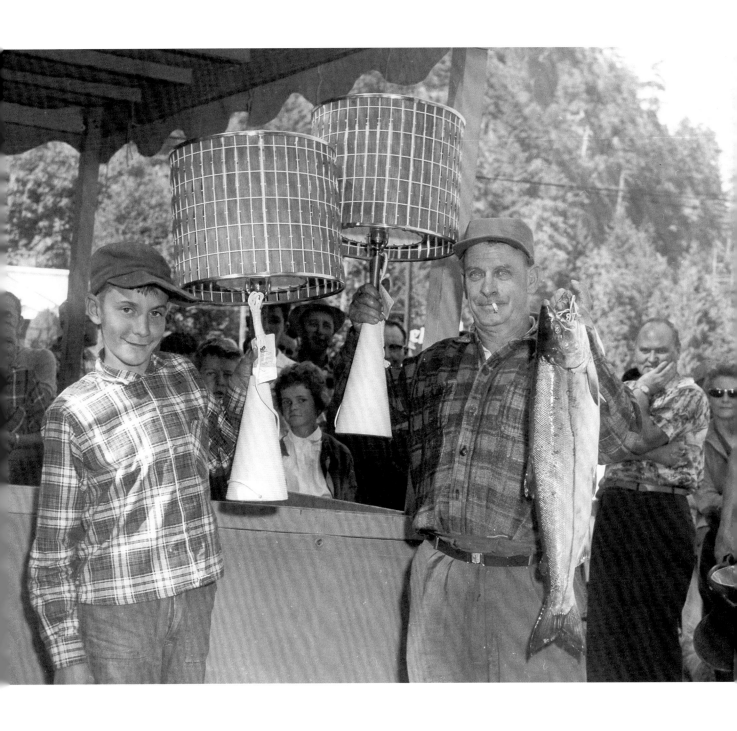

John McGinnis, *Burrard Dry Docks Annual Salmon Derby: G. Ritchie and son, 3rd Prize*, September 6, 1962, courtesy North Vancouver Museum and Archives [27-1111].

Una Knox. Top: *Orange Juice*, 2000. Bottom: *The Legion*, 2000.

on location

Marina Roy

Photography freezes the flow of experience. A snapshot can reproduce the random spatial and temporal coordinates of various locals, recording and constructing the contingencies of a social landscape. A fragmented, open-ended topography of signs results. Una Knox's photographs appropriate older spaces so as to record a sense of being suspended in another time, of remaining rooted in space. The subjects of *Legion* and *Orange Juice* are chiefly objects, a system of objects and images that seem to carry on an existence independent of their viewers. The presence of the solitary individual emphasizes alienation from this universe of signs, or a certain constraint under the power of their relentless gaze. We get the feeling that these individuals carry on routinely within these postwar-era spaces. In our present time, when a building, business, or organization can materialize just as quickly as it can melt into thin air, there seems little room for any long-term community. But in these photographs there is a sense of something enduring.

Sedentariness and routine are seldom compatible with the idea of global power structures. Historical migration seems to have swung from nomad to settler to nomad again. Such flexibility usually means that the local is degraded. Many move to accommodate the shifting tides of the economy. Those who don't get left behind. The same can be said of objects. They tend to weigh us down. We cast them off continually. In *Legion*, an octogenarian woman sits in the jaundiced glow of a Royal Canadian Legion Hall drinking beer, overlooked by two British icons, the queen and a bobby. A travel advertisement is frozen on a TV screen. With a dwindling military complex, a dwindling, aging clientele. Occasionally a younger generation might venture within to get one last dose of a marginalized community, an endangered way of life.

In *Orange Juice*, a restaurant set up as a tourist attraction in its display of "Indian" kitsch and hand-carved objects has been reclaimed by the local population. A theme-park system of objects and signs takes on a cult status for a heterogeneous gathering of regulars: a postmodern walk down postwar memory lane. To know something as kitsch is to feel authentically about the inauthentic. But this experience is complicated by the centrality of the young girl sipping juice at the counter. She's from the First Nations community that lives close by and appears very much at home in this environment. Culture and identity are constantly shifting, being reinvented. What was once culturally colonized can be re-appropriated as a source of symbolic power. The idea hits home when one notices the sign above the girl's head, on a shelf lumbered with carvings and bric-a-brac: it reads "Reserved."

The Caption and the Captioned

John O'Brian

The protagonist of E. Annie Proulx's book, *The Shipping News*, is a reporter in need of advice about how to compose an effective headline. A dark horizon does not spell rain, he is told, it prefigures a violent storm threatening the village. In a similar way, the viewer of Bill Cunningham's photograph, *Untitled*, is in need of instruction about how to compose a newspaper caption. Cunningham was a staff photographer for *The Province* from the late 1940s to the mid-1970s, and it is likely — though not certain, for the documentary evidence is missing — that the photograph ran in the newspaper accompanied by an obligatory caption. The purpose of the captioned single photograph, a staple of newspaper photojournalism before and after the Second World War, was to recount a punchy story. Photographs like Cunningham's *Untitled* were produced to be "signposted," as Walter Benjamin remarked in 1936, in his essay "The Work of Art in the Age of Mechanical Reproduction." They were not produced as images for "free-floating contemplation."

In the decades since Cunningham produced *Untitled*, the photograph has become estranged from its origins. The signpost that once underwrote it, the caption that offered viewers a fast entry into this image of a now unidentified man and woman locked in an embrace of laughter, has been lost. Forty years on, I am disinclined to supply a new one. The photograph that first reached a public audience on printed newsprint with a caption, now reaches audiences as a silver gelatin print in a frame. Any freshly minted title risks normalizing the uncanny. Although the photograph was provided with a bracketed caption line, "(Couple Laughing at a Dance)," in the *Facing History* exhibition, the label was for purposes of identification only. The bracket announced that the viewer's gaze was free to wander and wonder.

I think the photograph should remain unmoored, allowed to drift on a sea of free-floating signification. While some people may wish to conjecture about what provoked the shared joke, which can never be recuperated with certainty, others may wish to speculate on the big-band hotel location where it was shot in Vancouver. Myself, I am drawn to the man's three rows of teeth biting at the hotel wallpaper — that, and the clenched eyes of the two figures, who seem on the point of drowning.

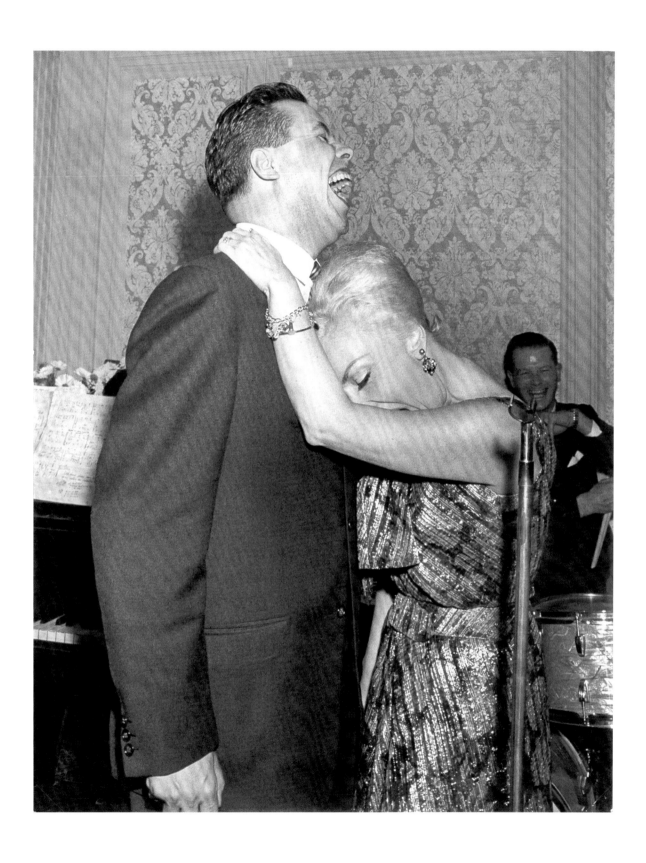

Bill Cunningham/*The Province*, n.d., courtesy Pacific Newspaper Group and the Cunningham family.

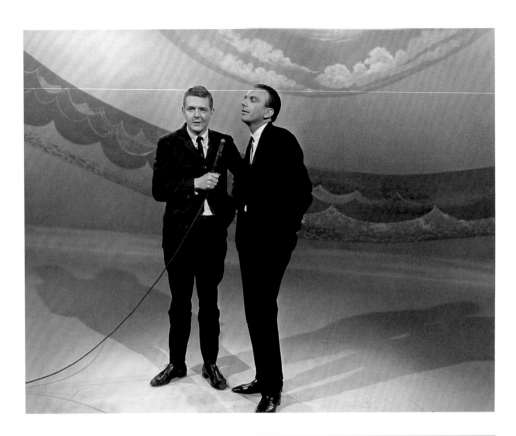

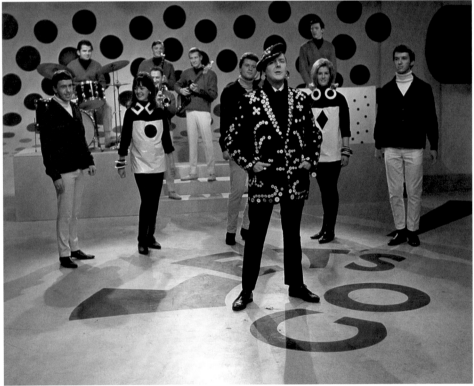

Alvin Armstrong, *Red Robinson*, host of *Let's Go* and *Music Hop*.
Bottom image: October 28, 1966. Courtesy CBC Vancouver.

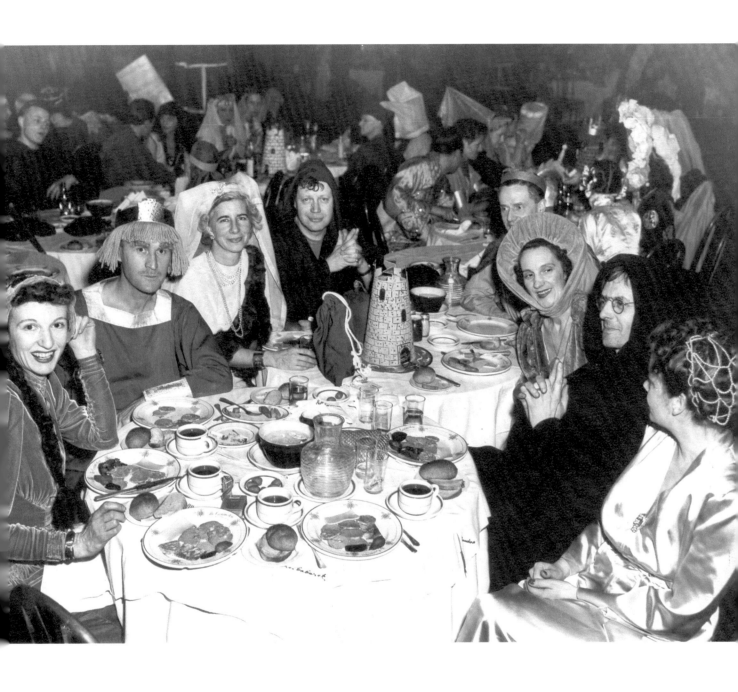

Bill Cunningham/*The Province*, *Beaux Arts Medieval Ball*, c. 1950s,
courtesy Pacific Newspaper Group and the Vancouver Art Gallery.

Backlight Compensation Blues

Wayde Compton

The hail, over and divided by
the Uhura factor. The power
of one divided by the black-faces-in-high-places policy,
the Franklin doctrine: peanuts versus shells. Peek-a-boo,

here-we-go-gathering,
look-a-Negro, swing low, sweet
rep-resent-ation, coming for to carry me
through a glass
darkly. Seeling,
sideways glance: darky? Reeling
from the elevation, the Civil x
travaganza, or swivel Rights
(the Great Pelvic Shift),
channelling: awopbopaloobop
alopbamboom.

The tokenism must go on.

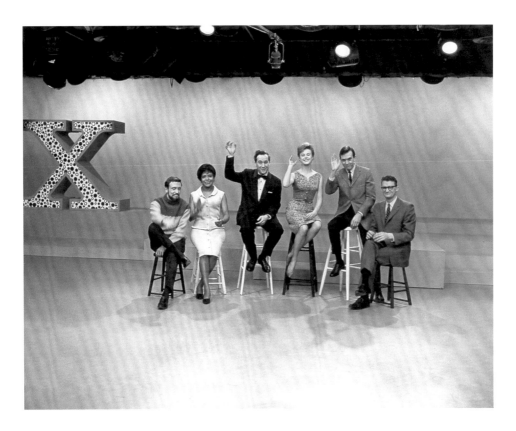

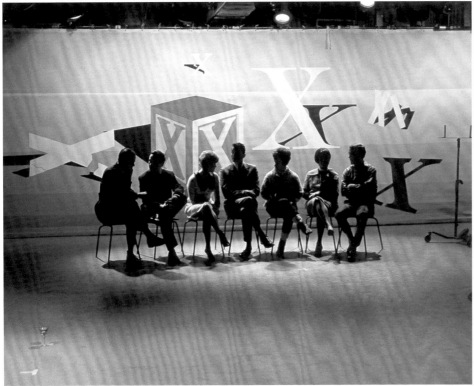

Alvin Armstrong, *X*, satirical revue/music show which began in 1966,
(David Hughes: "I like to think of it as a state of mind"), courtesy CBC Vancouver.

Mike Love. Left: *Dan Griffith*, 2000. Right: *Eric With*, 2001.

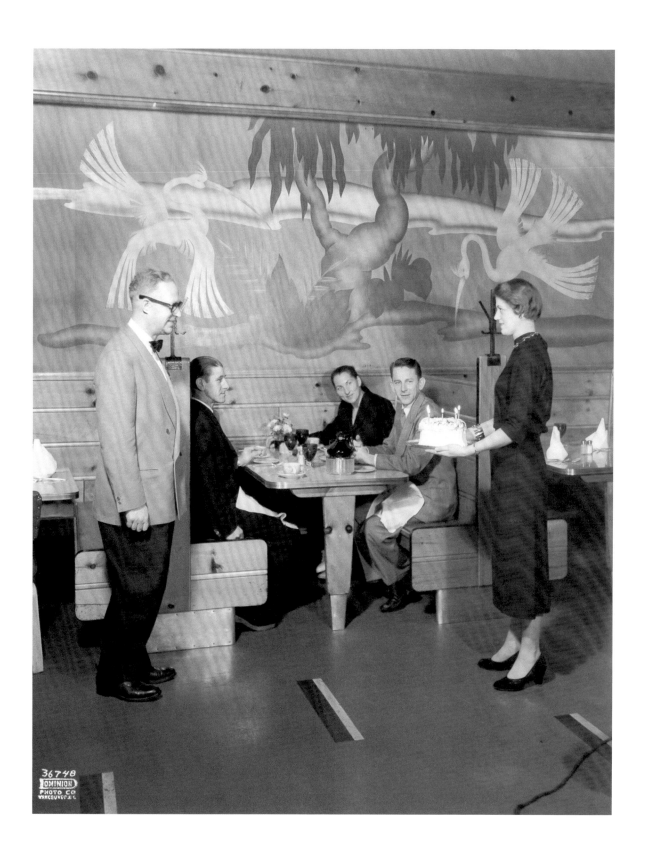

Percy Bentley/Dominion Photo Co., *Birthday Party at the Delmar Restaurant, 70th & Granville*,
November 16, 1953, courtesy Vancouver Public Library/Special Collections [29016].

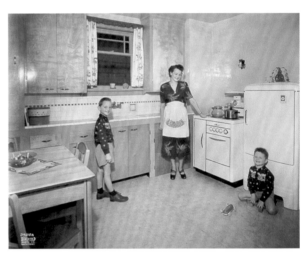

Percy Bentley/Dominion Photo Co. Clockwise from upper left: *Piggly Wiggly Store*, May 2, 1952. *Burrard Construction Supplies Ltd.*, April 16, 1956; *Advertisement*, November 24, 1950; *Canadian Bakeries Ltd.*, July 7, 1954; *Bonar & Dennis — Double Sack Assembly*, January 18, 1955; *Dayton Shoe Manufacturing*, March 1950. Courtesy Vancouver Public Library/Special Collections [28736, 29348, 28443A, 29125, 29210, 28145].

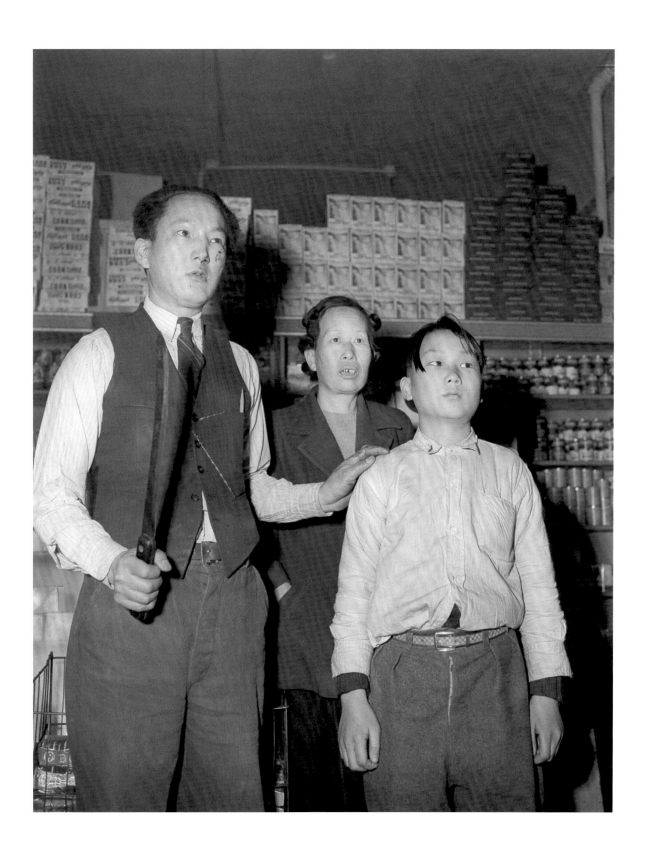

Art Jones/Artray, *Interior, Wong's Grocery, 500 East Pender Street, portrait of Chinese family who routed robber*, 1950, courtesy Vancouver Public Library/Special Collections [81131].

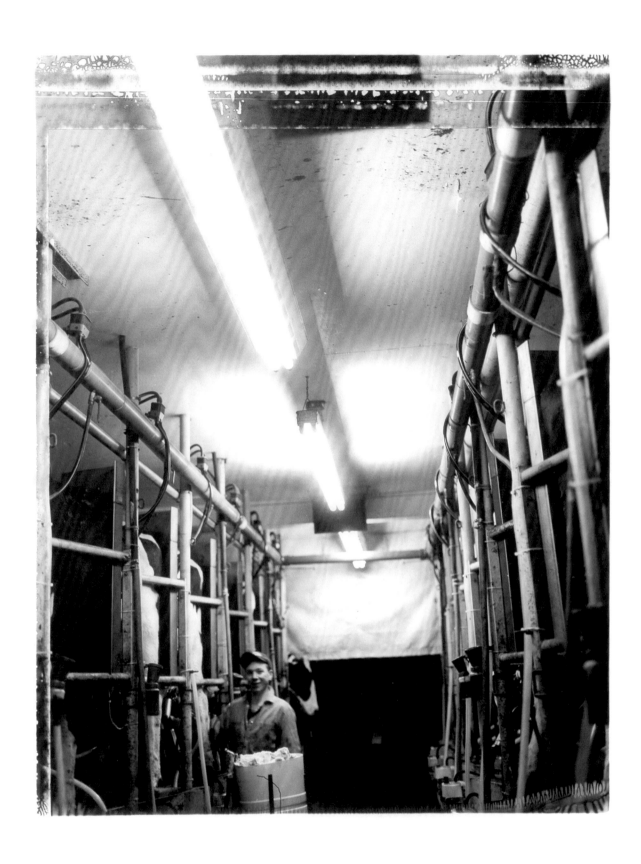

Ann Park, *Mike, Davidstead Farms, Milner, B.C.*, 2001.

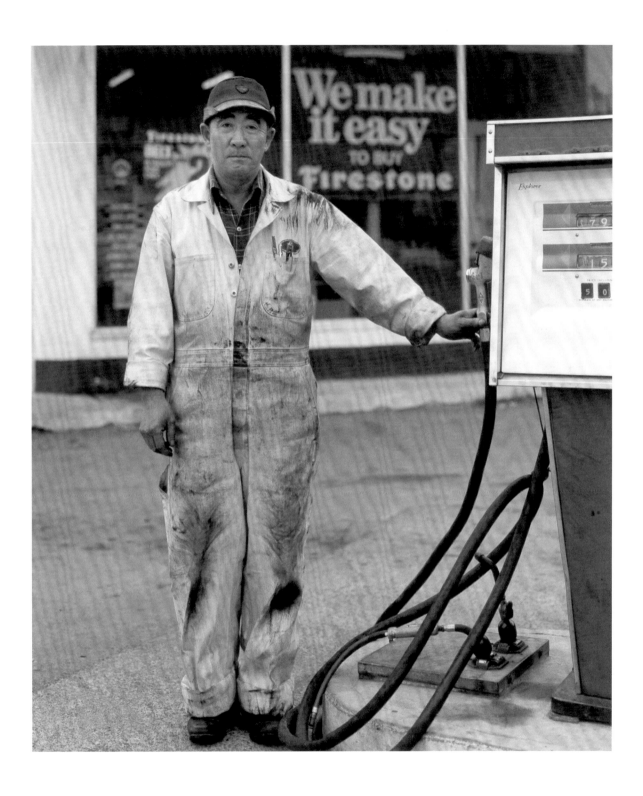

Robert Minden, *Worker, Marine Garage, Moncton Street*, 1973, from the book *Steveston* by Daphne Marlatt and Robert Minden, Ronsdale Press, 2001 (first published in 1974 by Talonbooks).

Woman Driver

Sarah Milroy

It could be called *Portrait of a Woman in the Prime of Life*. Cutting a dashing figure in her camel hair coat and matching gloves, Doris Shadbolt, aged fifty-two, is behind the wheel of her MGB. "I remember feeling good about that car," she says today, from her home atop Burnaby Heights, overlooking Vancouver. "It was cream coloured, a convertible, with a black top. I remember thinking it was pretty sharp."

In 1970, when this picture was taken, Shadbolt was senior curator of the Vancouver Art Gallery. She had arrived at the gallery twenty years earlier to take a job as docent in the education department. ("God, how I loathed that title," she remembers today. "It suggested such an ancient way of thinking.") By the time she left, in 1975, she was associate director.

The idea of posing in the car, she says, came from the photographer, Fred Douglas. He had been commissioned by the gallery to take portraits of staff members, and the pose reveals a lot about his perceptions of the woman, who was older than him by several decades. Clearly, he was a photographer in thrall.

She turns to fix us with her gaze, her hand on the wheel, and a subtle smile warms her lips. She knows exactly where she is heading: anywhere but here. It is we who must wait to find out the destination. The rain, which beads on the car's shiny surface, deepens the photograph's sensuous appeal. A drawling one-liner seems to melt in her mouth, like a pat of chocolate.

If the car was sharp, the driver was more so, and in the sweep of her estimable career, 1970 was a particularly banner year. A landmark exhibition of conceptual art, titled *955,000* and curated by Lucy Lippard, had opened at the gallery on January 13, and Shadbolt had been intimately involved in all aspects of its development. Shadbolt had already established her reputation as a curator bent on bringing the world to Vancouver, and vice versa, with her previous shows *Los Angeles 6* (1968) and *New York 13* (1969), and her *Arts of the Raven*, in 1967, had been reviewed glowingly in the pages of the *New York Times*.

In 1970, she also staged a retrospective show of work by the London, Ontario, painter Jack Chambers at the VAG, and was making preparations for her centennial exhibition of the art of Emily Carr for the following year, an exhibition that would mark her first in-depth scholarly encounter with the British Columbia modernist. (She would go on to write two major books on the artist.) *Sculpture of the Inuit* (with George Swinton and John Huston)

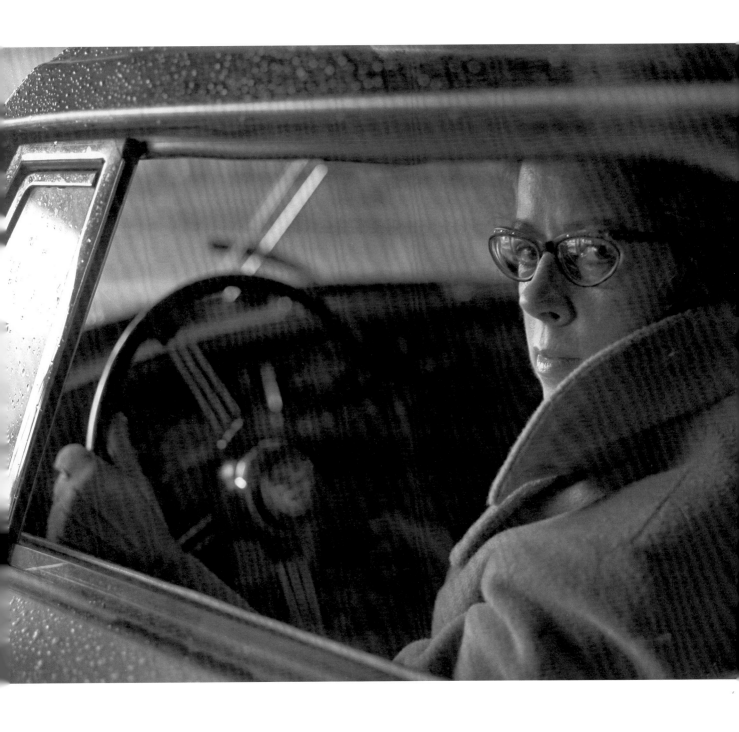

Fred Douglas, *Portrait of Doris Shadbolt in her car*, c. 1970.

was also in the works, a pioneering curatorial effort to find a critical language for the art of Canada's far north, and to hammer out some of the ethical issues surrounding its dissemination in the south.

Whatever the rigours those days may have entailed, they clearly agreed with her, and she remembers the period with great fondness. "The gallery was so alive then," she says. "When we opened a show like *New York 13*, there would be lineups all the way down the block to get in." Art was moving forward so fast, she says, "and we were a part of it. We were in the lane that was moving."

And in the driver's seat, no less.

Fred Douglas, *Gail Kendall, software specialist*, mid 1970s.

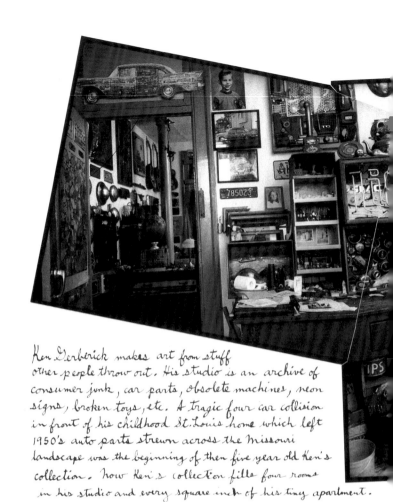

Ken Gerberick makes art from stuff
other people throw out. His studio is an archive of
consumer junk, car parts, obsolete machines, neon
signs, broken toys, etc. A tragic four car collision
in front of his childhood St. Louis home which left
1950's auto parts strewn across the Missouri
landscape was the beginning of then five year old Ken's
collection. now Ken's collection fills four rooms
in his studio and every square inch of his tiny apartment.

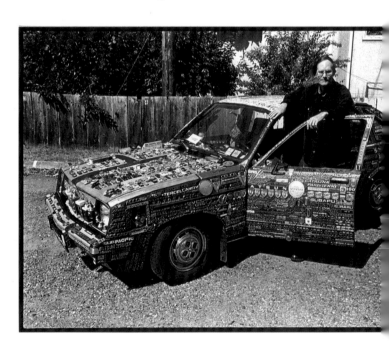

Henri Robideau, *Ken Gerberick*, 1996, assemblage with b/w photographic prints and handwritten text.

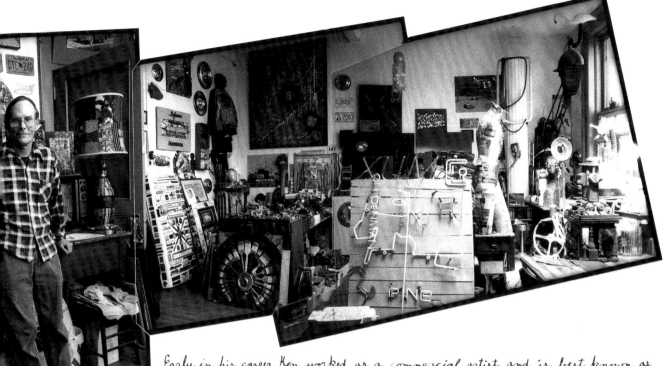

Early in his career Ken worked as a commercial artist and is best known as the designer of the 1964 Anheuser-Busch 10,000,000th barrel of beer commemorative medallion. Commercial art stifled Ken's creativity so for relief he turned to recycling his collection of junk by making his now-famous assemblages.

Apart from his assemblages Ken has made two ART CARS. The first was a 1957 Pontiac named The Emblem Car. His latest street machine is an 84 Chevette known as The Frivolous Niece of the Dowager Emblem Car or the Frivolous Niece for short. She's covered with 2,000 emblems and roofed with 37 license plates. On the hood is a model junk yard which has 175 toy cars glued to it. Frivolous Niece won 3rd place in the Small Vehicle Class at the 1996 Houston Texas International Art Car Exhibition.

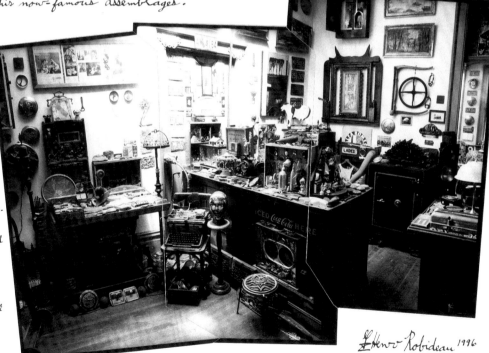

Eleanor Robideau 1996

95

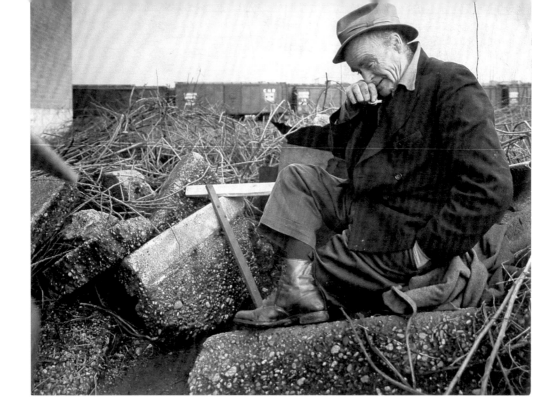

Bill Cunningham/*The Province*, both photographs untitled, n.d., courtesy Pacific Newspaper Group and the Cunningham family. (Bottom: far left: Mayor Bill Rathie; second from right: George Wainborn.)

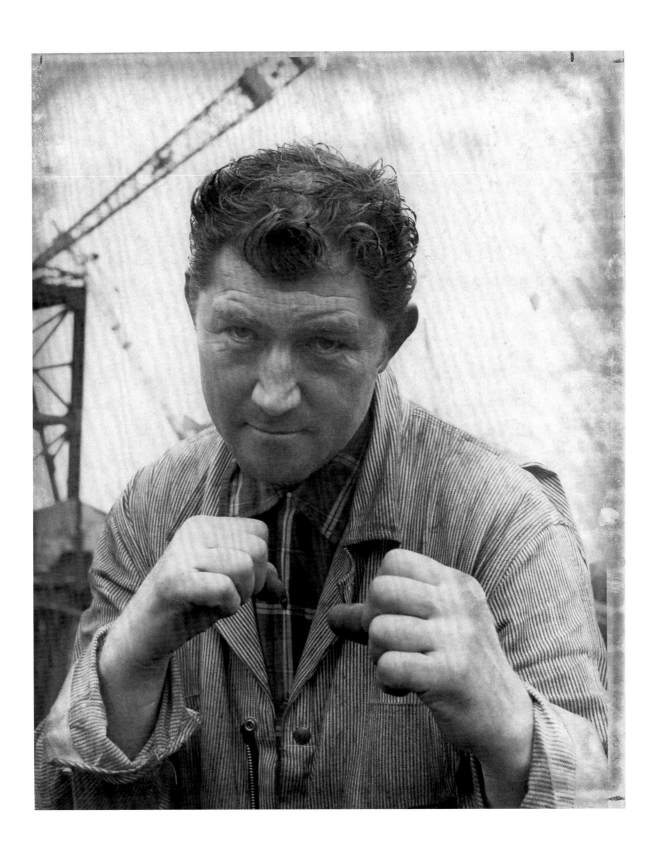

John Helcermanas, *Burrard Dry Docks: Elio Ius, Burrard rigger and amateur boxer*, 1970, courtesy North Vancouver Museum and Archives [27-809].

Alberta foothills, and all you had to do was keep the nose of
the boat pointed into the trail, ~~you could just amble acro~~ss
~~the morning of eternity itself~~) while the wind still
swept past in jet-streams low and fierce as a winter
~~g~~ blizzard ~~laying long lines of streamers~~ laying long lines
of streamers across the waves.--~~and~~ You could just barely detect
a slight absense of steamers directly ahead, like a windprint
of the boat...Our wake ~~was~~ lay ahead of us ~~and~~ and we were
driving back into it...And it was a gentle angel-cradling
motion, a feather movement, a love-act.--"Gotta watch this
kind of thing," said John, spoiling the mood because he looked
no less uptight than he had ~~when~~ when we were plowing head-on--
~~stern following~~ "What's the danger now, John?"--"Wal, ~~when~~ ya
get a following sea like this and ~~you don't~~ y'don't have ~~to~~
t'work so hard, if you know what I mean. But ~~if~~ y'can get
caught nappin'. Them waves 'r still out there, even if y'can't
feel 'em so much on account of we're not jogging ~~anymore~~
into 'em any more. But the stern ~~g~~ ain't built like the bow,
~~it~~ y'know, and y'don't have to take too many of 'em over the
stern 'for she starts to break up..."--So we ~~handle~~ handle the
wheel like a great butterfly, stroking her wings, breathing
on her antennae, holding the wheel oh so gently and just trying
to let the bow flow the way she wants into the wake, just ~~making~~
making tiny adjustments whenever the ass-end swings out too
much--And ~~if you watch the way the water opens up at the stern~~
you can feel the tons and tons ~~and tons~~ of water pulled by
planetary forces opening and closing like ~~some enormous~~ vast dark
lens at our backs.--Cheerfully, somebody remarks: "The sea
is rising up hungry behind us and coming at our ass."--Which
was close to the centre of the mood.--For a whole day we ~~ride~~
~~the current~~ drift thru The Angel Dance of The Following Sea,
Rod and I chortling over the idea that maybe fate has decided
to take a hand in things, and isn't the wind driving us
back directly towards Amchitka? And wouldn't that be the final
grand piano if we got deposited by the storm on the doorstep
of Cannikin the day the beast emerged clad in its isotopes
and Hiroshima ~~funk~~ Glitter?--Williwaw, the cat, gets over her
seasickness and takes to ~~i~~ moving from bunk to bunk, seeming
to sleep with whatever guy is feeling the most down.~~--she had~~
~~a knack~~--It was strange, but Williwaw had a knack for going to
bed with ~~the~~ whoever needed her most~~n~~ at the time. For a long
while, it was Terry, then Ben, then Cummings. She gave us
each our turn to sleep with her ~~in~~ furry ~~warm living~~ living
warmth.--~~And~~ No one will ever convince me that cats are not
psychic.--In time, the storm swept past us. "Hard around!"
barked John, ~~Web~~ churned wildly between the troughs again,
then the Phyllis Cormack straightened, like a gull wing,
~~extended from wing to wing~~, and ~~she~~ started whacking her
axe-bit of a bow back into the surges of sea.--"Got 'er
licked now," said John...And on we sailed into Juneau...
Where the Governor of Alaska sent a message saying, "I'm
glad you made it back into these waters safely. I admire
your courage in carrying out your convictions and I think
you have proven your point."--But he did not have the time to

Robert Hunter, excerpt from an unpublished book manuscript about the first Greenpeace trip,
an anti-nuclear protest voyage to Amchitka Island, Alaska, in 1971.

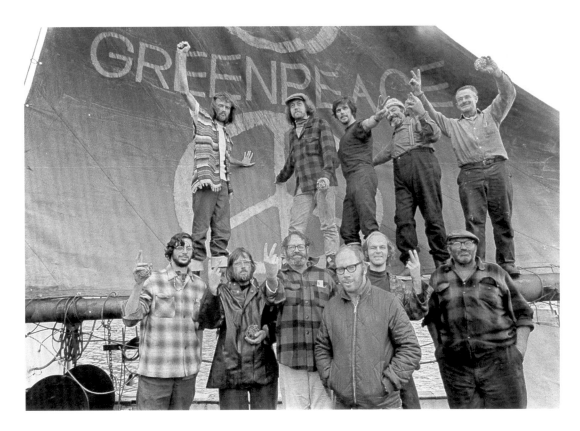

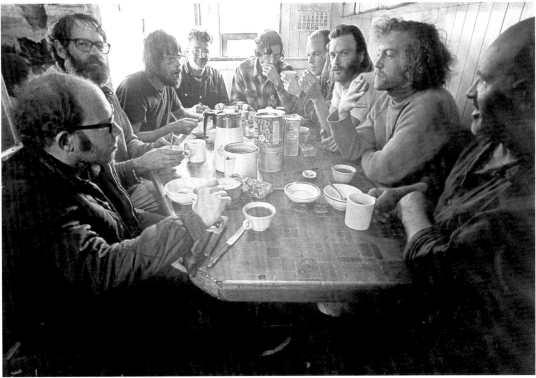

Robert Keziere, *Greenpeace: Voyage to Amchitka*, September 1971. Top, clockwise from upper left: Robert Hunter, Patrick Moore, Bob Cummings, Ben Metcalfe, Dave Birmingham, Captain John Cormack, Bill Darnell, Terry Simmons, Jim Bohlen, Dr. Lyle Thurston, Richard Fineberg. Bottom: *Crew on the Phyllis Cormack*. Courtesy Robert Hunter, and Greenpeace.

father's voice

*A family is like
a small nation
to me. When my
grandfather Andrew
came to Canada
from Ukraine he
brought with him
pain and suffering
from decades of
brutal wars over the
deep rich soil of
Ukraine; from the
imposed slavery of
the overlords. He
brought his history.
Like him, I am a
loner. I can handle
people at an arm's
length. I really can.
After the heart attack
my boundaries are
down. I can trust
people. The
problems of trust
in relationships are
the same as the
problems of trust
between nations. I
want so profoundly
to see the boundaries
between nations,
between peoples
removed.*

daughter's voice

*Dad, you have
taught me that
home is where you
have choice. For
Ukrainian people,
Ukraine has not
been home for
many generations.
They have been
exiles in their
own land. As a
Canadian of
Ukrainian ancestry
I carry that sense
of exile learned
from my
grandparents and
from you. For me,
freedom of
Ukrainian people,
their independence,
is an assertion of
the right to have a
home and the right
to make decisions
in that home.
Boundaries define
the territory (both
inner and outer)
that we call home.
Love is the
recognition of and
respect for the
home of another
individual, people,
or nation.*

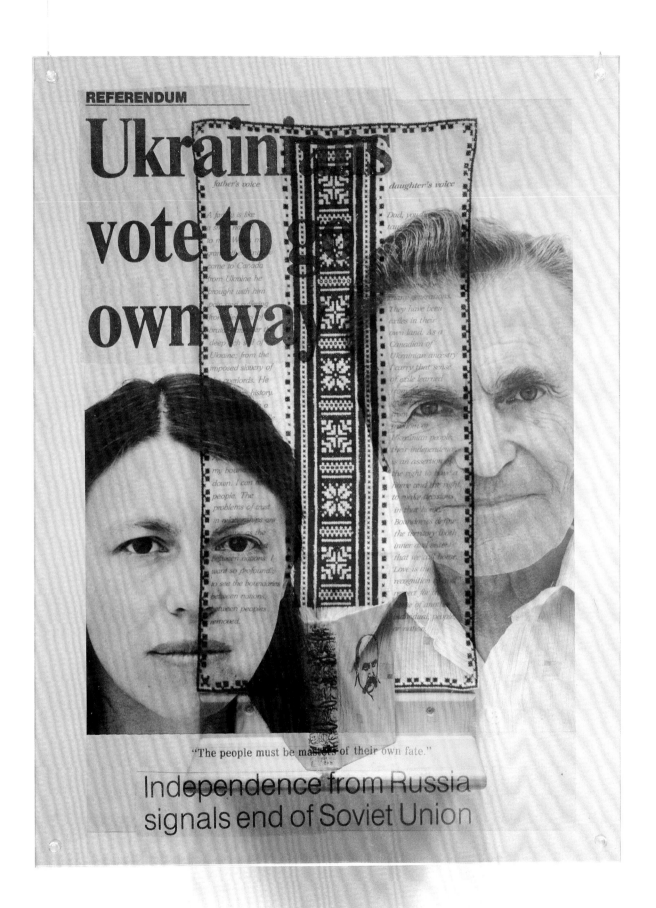

Sandra Semchuk, *Ukrainians vote to go their own way* (daughter/father collaboration with Martin Semchuk), 1990, acrylic sheet, laser transfer, wooden shelf, book, embroidered cloth.

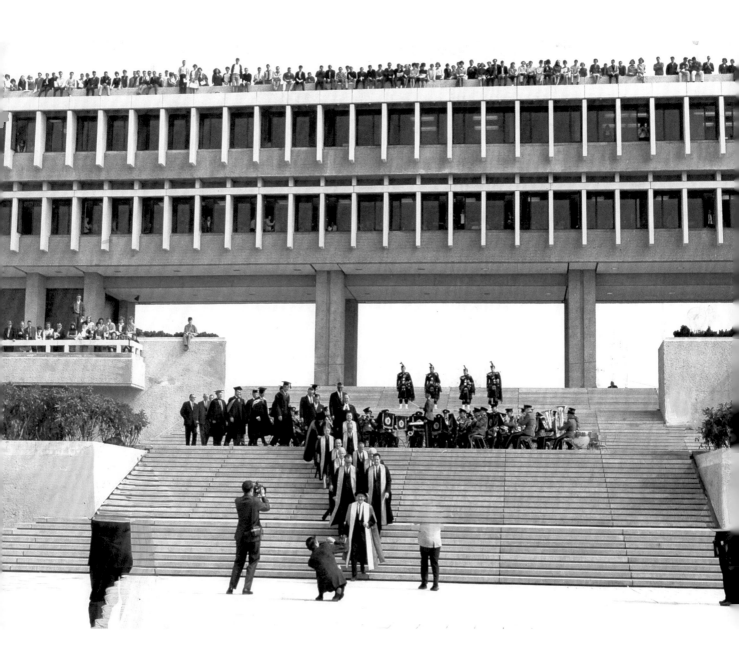

Bill Cunningham/*The Province*, *"Students line roofs at Simon Fraser University to watch ceremonies but police later forced them to leave,"* September 10, 1965, uncropped photo showing adjustments made for publication. Courtesy Pacific Newspaper Group and the Cunningham family.

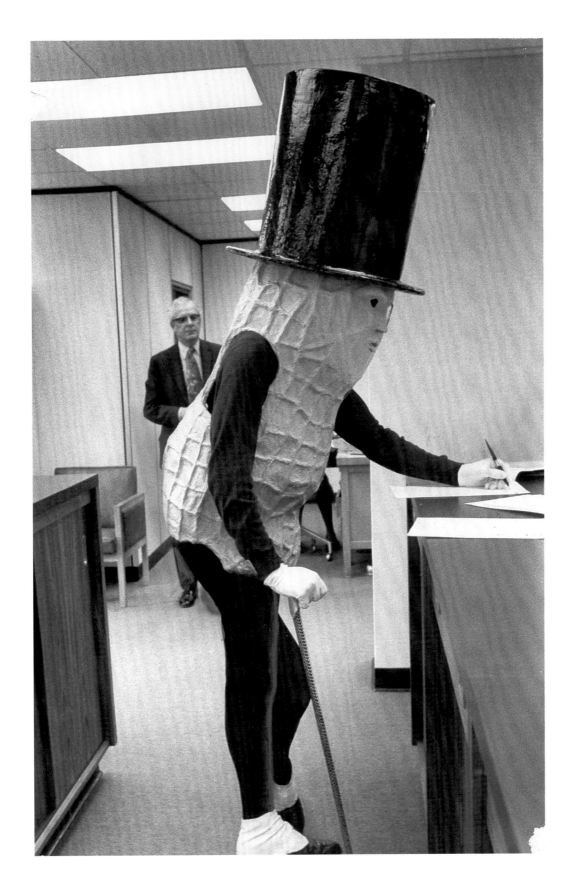

Brian Kent/*Vancouver Sun*, *"Peanut Candidate, artist Vincent Trasov shelled out $200 deposit and filed nomination papers at City Hall today. Late entry in mayoralty race declined comment but a supporter said he would be Peanut Party candidate because 'people are used to electing nuts,'"* October 30, 1974, courtesy Pacific Newspaper Group.

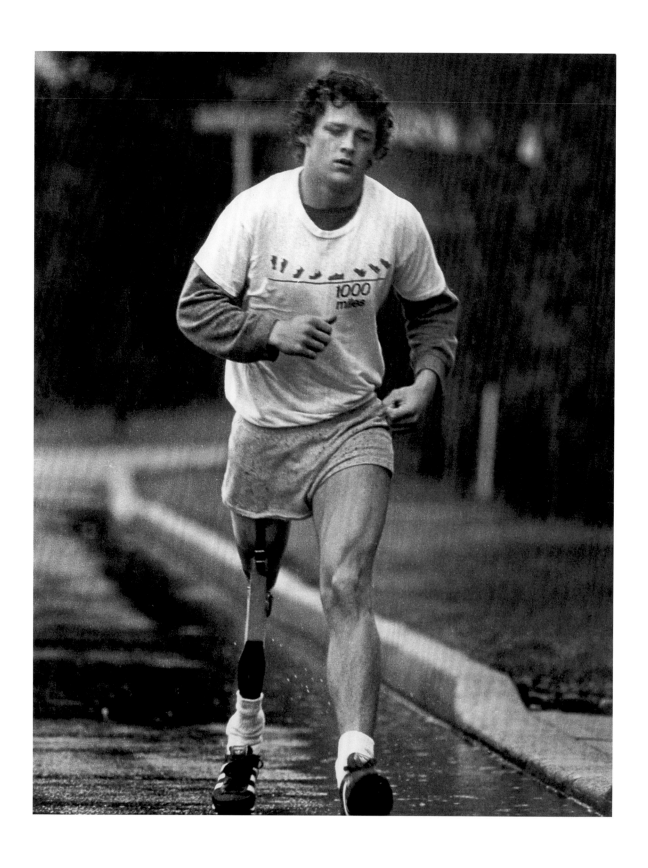

Colin Price/*The Province*, *Terry Fox — Marathon of Hope*, July 3, 1981, courtesy Pacific Newspaper Group.

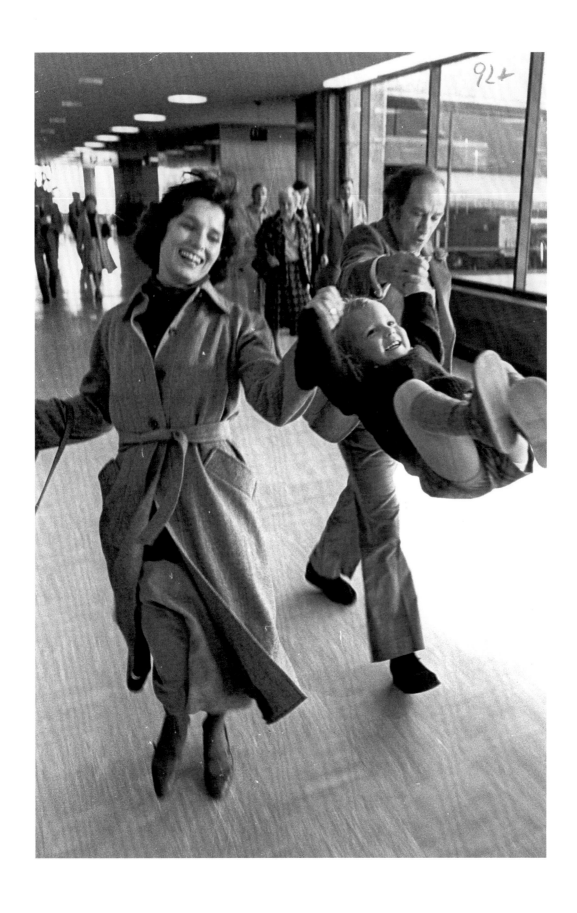

Doug Ball, *"Swing To The Orient: Margaret and Pierre Trudeau swing 2-year old son Sasha . . .*
Vancouver International Airport," October 20, 1976, courtesy Canadian Press.

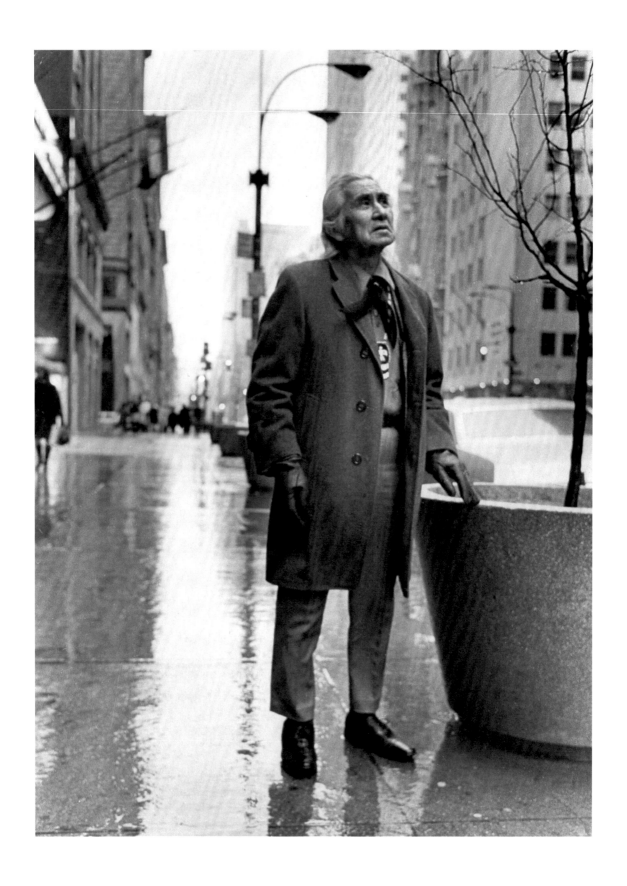

Photographer unknown/*Vancouver Sun*, *Chief Dan George*, December 16, 1970,
courtesy Pacific Newspaper Group.

Subject: Volvos on cobblestones
Date: Mon, 24 Sep 2001, 01:41:42 PST
From: Brian Jungen <brianjun@telus.net>
To: lb@telus.net

It is tricky to type on a Finnish keyboard, as there are extra keys with symbols I don't understand. This leaves me pecking out this note. I am also using the computer in the children's workroom at the Museum, which means I am sitting on a tiny chair. No trees along the streets, just Volvos on cobblestones and shitty skate-boarders. Everyone here is well dressed and polite. It's so true what Geoffrey said about Scandinavia being like the movie *Gattaca*. I like a more diverse pool, not just designer looks. There is no street vibe, in fact pedestrians look miserable. The other artists will be drifting in all week, no one sexy, but I did see an interesting fag, he was wearing a knee-length wool cardigan, over what looked like bandaged legs, shaved head, and taupe slipper-things. He gave me that look which I did not return. I went to a gay bar called Hercules, where all the men are tall and slight, and most wore lozenge-sized glasses. It is hilarious watching the Finns get drunk and attempt to dance to trashy Euro-pop. Like everything here, spontaneity seems to require a group decision.

I wish I had a computer in my hotel room, it would make my pre-dawn wakenings a little less lonely. I still find it hard to stay awake past 8pm, and last night I passed out before 6. I went for a long walk around Helsinki this morning (4am). Vacant glowing streetcars, whiffs of diesel from street-sweeping vehicles. I have been meeting new friends, but everyone is on different time zones. Yesterday I was photographed so many times, I stopped noticing. The catalogue is of *de rigeur* international design, with non-threatening writing. Kitty wrote something for a Japanese artist, and Jeff's piece on my work seems cluttered with the term 'global.' Breakfast buffet on tenth floor at 7am. Portly German businessmen hogging the meat and cheese island, I was left with museli and luminous fruit salad. I wish you guys were here. There are no Brits or Americans yet, and everyone else is so serious.

I am typing this on an ancient laptop. My hands are slowly returning to room temperature after a brisk walk around Helsinki. +3 degrees, sun so bright it hurts. I had a good ten-hour sleep, interrupted by an Ativan dose. I have no energy now for creative observation, I just want to get this over with. I realize I really don't like many aspects of the business I am in. Hope to see you soon; I will try to convince myself that I am having the time of my life.

I don't know if you would like a Finnish man, they are very stiff in their bodies. I want to swing on a bar like at Third Lake.

Roy Kiyooka, *Powell Street Festival*, 1983 (diptych), courtesy Catriona Jeffries Gallery.

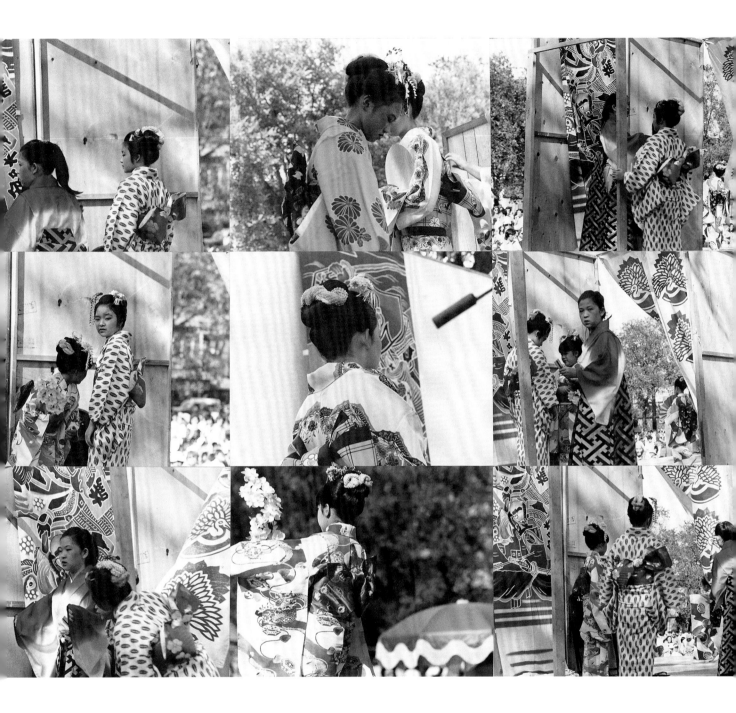

The Young Kid

Roy Miki

The moment he laid eyes on the scene he thought he could recognize its import. The minimalism of the gestures — the eyes and hands, of course, but the cocooning effects too — offered stories that seemed to call for reckoning. In the old sense? But that was just subjective musing on his part. In this more material instance the pattern of relationships, which had been mobilized with such acumen in the postwar years, those nestled in memory as the cradle of possibility — had been translated into a mediated phenomenon now dubbed the "reinscription." Thus signing one's own name, even given the more soft hued nomenclature adopted by the white-collar gatekeepers, could stand in as the tell tale aura that the nation — yes the nation — had entered, as if momentously, a state of desire for a human face. The more explicitly complicit social archives aside, it is the interior of that era with which the photo is fortunately — but is "aligned" the term he wants? He couldn't say for certain. Except that the face posited itself between the pillars of a "support system" and what can only be described as "the uncanny." The tension, of course, always depended on the provisional identity formation of the young kid in question. In other words, is "he" a figure of destiny or chance? As he gazes at the hand of the man who incarnates the historical process, holding in his hands the artifact as proof, he does not look at the authorial centre who — caught in this reflection of his power — cannot re-articulate the gaze. This event, then, may be construed, but only tentatively, as the birth of the multicultural. Look again closely at the conjunction of all the bodies held in place by the image of the image. The hand signing, inscribing his name as the extension of the frame, produces a social relationship. He thought of a photographic inset of the future yet to be — yet to be because the nation, in a symbolic twist, here writes its story on the virile poster and not in his memory. So when he was a kid, or no, when he was that kid, he couldn't decipher the lingo of his own visibility. He thought he had lost his vocabulary for at least three decades. But then, in a period of idleness, the kind made available in a found image that returns the time of history, he saw himself in the absences necessary to the surge of the very gestures so apparently captured. It was as if the slippages had yielded a prescience in which the nation had appeared as his double. As a kid, the technique had been lacking. Only an inkling had formed on the tip of his tongue, some hesitancy that had no name, more undertone than an event to be commemorated. For the time being, at least, he could ride the crest of the nuances, waiting for the arrival of the photographer.

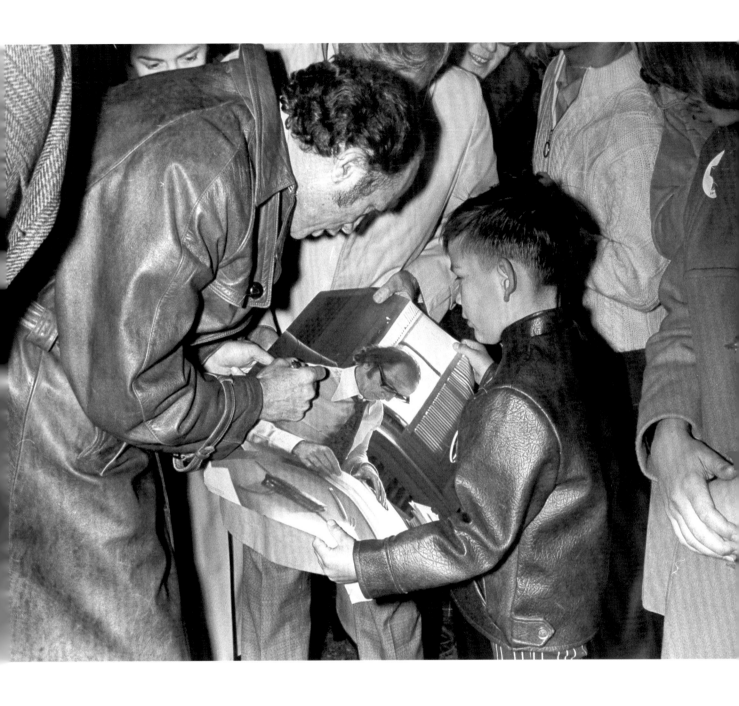

Glenn Baglo/*Vancouver Sun*, *Prime Minister Trudeau signing autograph for young boy*,
October 14, 1972, courtesy Pacific Newspaper Group.

I WILL
GESTURE
THUS,
SPEAK SUCH
AND SUCH.
I SHALL
BE THE
MASTER
OF PRETENCE,
THE
DILETTANTE
OF
AFFECTATION,
SHE
MUSED.

Sandra Semchuk and James Nicholas, *coyutpolitics*, 2001, digital inkjet print.

THE
BIRDS
LAUGHED:
IT
WAS
ONLY
COYUT
INVENTING
POLITICS.

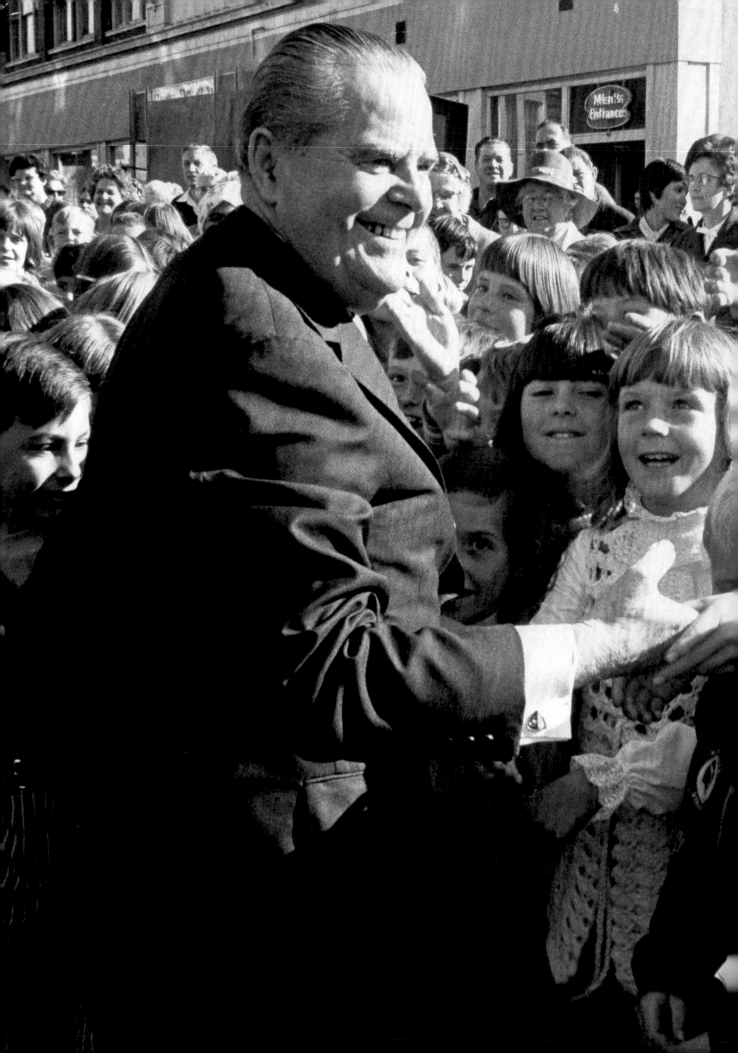

Jim Ryan, *W.A.C. Bennett*: "*Kids mob Bennett*," October 19, 1970.

George Smith, *Religious revival meeting, Broadway Pentecostal Tabernacle, 1363 W. Broadway*, 1952, courtesy Vancouver Public Library/Special Collections [83307].

Auditioning Minister
At The Broadway Pentecostal

Michael Turner

. . . picked me up from my slumber, blew the sleep from my eyes, the wax from my ears, and shook me. Shook me like I've never been shook before! Shook the skin right off me He shook me so hard. And my bones — like an ax striking a xylophone! That's how hard He shook me! Shook me until there was nothing left but my own unshakable faith! *Hababadoo ulunga fava!*

And I was putty. That's what I told Him, brothers and sisters. I said Lord, I am your servant; I am putty in your hands. To which he replied, "No, my son, not putty. The human spirit is not a synthetic compound; nor is it a leak-plugging device; nor can it be manipulated. The human spirit is no more complicated than love itself." And as we all know, there is no love in labour when it is knowingly used as a stop gap. All the caulking in the world cannot save the sinking ship, not with the wind blowing a hundred miles an hour, the ocean swelling a hundred feet high. Only faith can save such a ship. And as for stop gaps, they are predicated not on love but on capitulation, doubt.

Which is what I want to talk about today, and that's faith.

Before I awoke I had the most unusual dream. I dreamt of a time not too far from now, where all that we have come to know and love about this beautiful province of ours was taken from us by the most malicious of governments, a government who has so little faith in the ability of its citizens to co-author its future that it gave away our rights to those whose motivations are based wholly on profit!

The government in my dream was led by a man who boasted humble beginnings, a man who, rather disingenuously I might add, declared himself to be among the poorest of the rich, a

self-made man who, along with his brother, wheeled-and-dealed in the most sinister of professions: market speculation. Such success did these two have that the younger sought to further his work in the field of mass communications, as a mouth-piece for big business, while the older cloaked himself in the sheep's clothing that is public office.

And so it came to pass from this unholy trinity — this trident of communications, economics, and politics — that these two brothers converted the minds of everyday British Columbians, turning us against each other by invoking that ninety-yard dash called progress. But we are not sprinters out here in British Columbia, not like those rat racers out east. On the contrary, out here we are in it for the long-haul — and like our pioneer parents before us we aim to go the distance! No high-rolling sprinter is going to tell us what to do! We are not going to let decisions about our water and electricity be made by fat cats south of the border, just as we are loathe to discredit such noble professions as teaching and nursing as stumbling blocks in the name of free enterprise. *Halufalumptua Wee Malinga Ho!*

The future, brothers and sisters, is not a sprint but a marathon. And if we go a little slower than the rest of the planet, so be it. Let us work within the pace we have set for ourselves, and let the rest of the planet follow our lead. Let us have faith not only in our beliefs but in the fact that we have come upon our rhythms honestly, and that we will reach the finish lines we have set for ourselves on our own terms, bypassing those imposed from without. And finally, let our own pace be the foundation upon which we stand against this future government, for only then will we know that we are beginning from what is right and good in the world, and not some line in the dirt before us.

Let us sing . . .

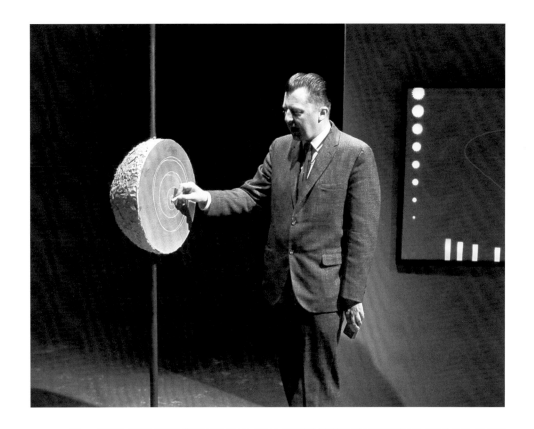

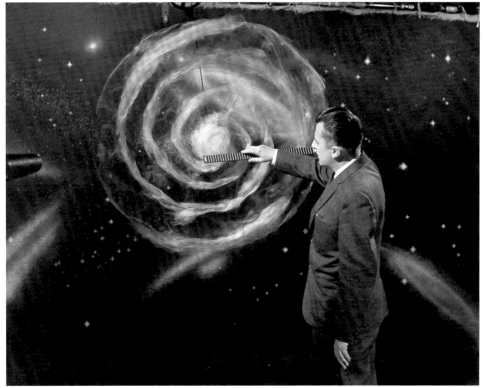

Alvin Armstrong, *Canadian School Telecast — Looking Into Space*, November 3, 1965,
production stills, courtesy CBC Vancouver.

Max Dean, two views of *So, this is it!*, 2001, electronic components,
video monitor, computer, courtesy Susan Hobbs Gallery.

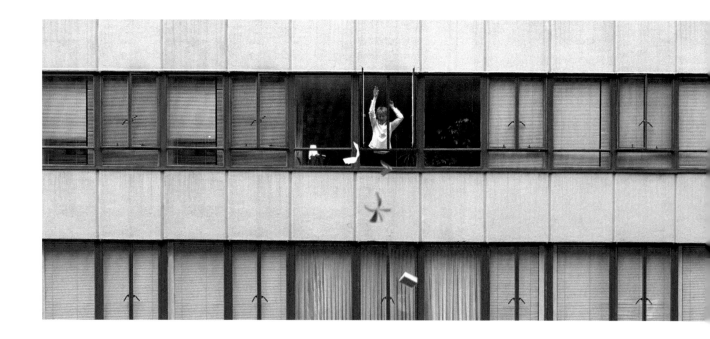

Short stories

Karen Henry

6:10 pm Subject, female, appears at the window of apartment residence off Granville Street, places a stack of books on the window sill, opens the window and peers down at the sidewalk. **6:11–14 pm** With no apparent provocation, subject picks up the books one by one and drops them from the open window. One falls on a man getting into a black car, resulting in a short altercation. **6:15 pm** Subject closes the window calmly and disappears from view. The books remain on the sidewalk. It's getting dark. Requesting permission to break cover and investigate. (report submitted 6:25 pm 17 September 2001)

She was totally immersed in academia and the history of art and its relation to social experience. As a student of the late twentieth century, Marxism had informed her view as had feminism and psychoanalytic theory. She was especially interested in urban architecture and geography. But recently she felt the urge to divest herself of all these associations. Where once they had reinforced her commitment, they now seemed like a series of walls she kept running into. Everything was different now. She wanted to start fresh, get rid of the excess. She carried the books to the window and dropped The Naked Ape *and a novel called*

Allyson Clay, *Double Self Portrait*, 2001, courtesy Catriona Jeffries Gallery.
*Commisioned by Presentation House Gallery and shown at the Seabus Terminal,
North Vancouver, in September and October 2001.*

Mind and Body

False Starts, *and for good measure she threw in* A History of Rome. *She held each one up and looked at it against the urbanscape, blocking out the view momentarily and then watching it grow smaller as it fell: a trope of perspective. She was so immersed in her pleasure that she let go of* The Art of Destruction *before she realized there was a man below. A poet who lived in the building, a guy who thought he knew everything. She watched the books falling, sometimes with their pages flapping and sometimes stoically, like a brick. She wondered how long they would stay away.*

THE WOMAN ABOVE ME IS A LITTLE ODD. SHE SEEMS NICE ENOUGH TO TALK TO BUT YOU NEVER KNOW WHAT'S GOING ON IN THEIR MINDS. I'VE SEEN HER WITH A CAMERA ON THE ROOF AT NIGHT FILMING THINGS. SHE DIDN'T KNOW I WAS WATCHING, BUT I KEEP AN EYE ON WHAT GOES ON IN THE BUILDING. YOU CAN NEVER BE TOO CAREFUL.

Allyson wanted to do this shoot so we had to set up a camera across the street and take photos while she dropped books out of the window. Sometimes they went by so fast we could hardly get them in the frame. We kept having to do it over again until we got it right. And then the light started to change. I loved it! We laughed a lot. All that effort to get the right shot, to control gravity. It was the perfect mix of order and chaos, nature and culture.

It's a question of architecture, how we move around the city, where we find shelter, establishing a point of view, who has a right to do what, where. "Is privacy possible?" she asked herself. Haven't we sacrificed our rights to a false god of security? We are watched, recorded, rationalized, and categorized. The image is all we know of each other. Erratic behaviour is duly noted.

Bill Cunningham/*The Province*, untitled (Doug McInnes, former Librarian, UBC/Woodward
Biomedical Library, holding *De humani corporis fabrica* by Andreas Vesalius,1543), 1969,
courtesy Pacific Newspaper Group and the Cunningham family.

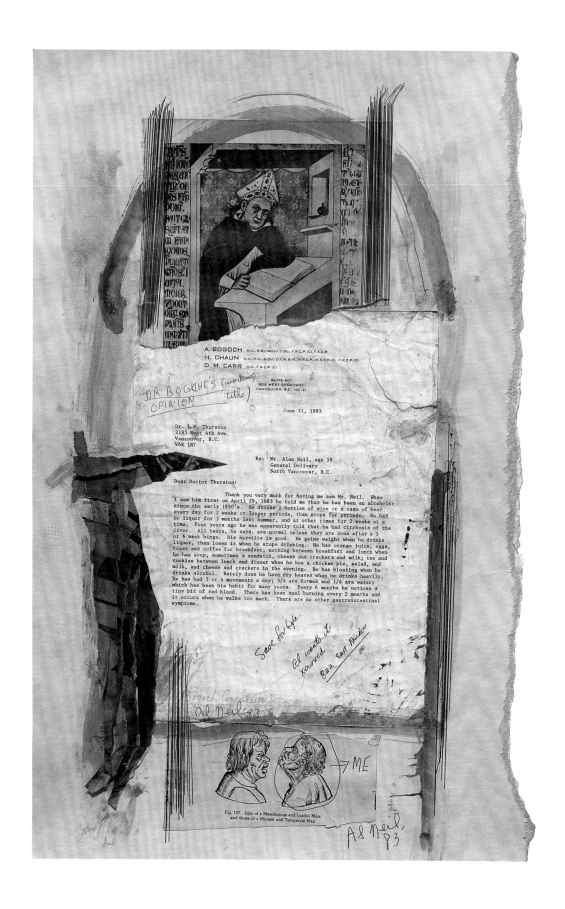

Al Neil, *Dr. Bogosh's Conclusion*, 1983 (triptych), collage on paper, courtesy Scott Watson.

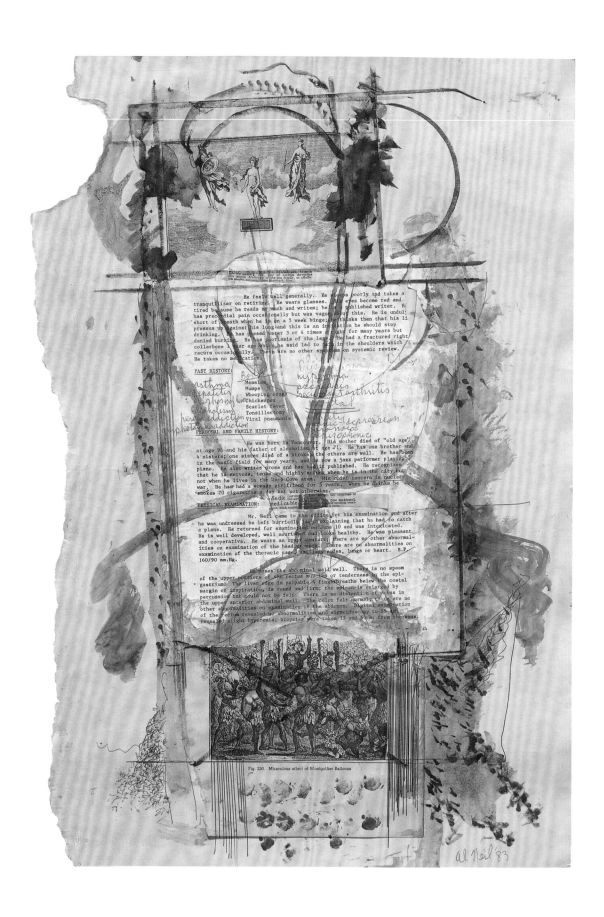

He feels well generally. He sleeps poorly and takes a
tranquilizer on retiring. He wears glasses. His eyes become red and
tired because he reads so much and writes; he is a published writer. He
has precordial pain occasionally but was vague about this. He is undul
short of breath when he is on a 3 week binge; he thinks then that his li
pressum up against his lung and this is an indication he should stop
drinking. He has passed water 3 or 4 times a night for many years but
denied burning. He has psoriasis of the legs. He had a fractured right
collarbone a year ago which he said led to pain in the shoulders which
recurs occasionally. There are no other symptoms on systemic review.
He takes no medication.

PAST HISTORY:
 Measles
 Mumps
 Whooping cough
 Chickenpox
 Scarlet fever
 Tonsillectomy
 Viral pneumonia

PERSONAL AND FAMILY HISTORY:

 He was born in Vancouver. His mother died of "old age"
at age 96 and his father of alcoholism at age 71. He has one brother and
4 sisters; one sister died of a stroke, the others are well. He has been
in the music field for many years, and is now a jazz performer playing
piano. He also writes prose and has had it published. He recognizes
that he is nervous, tense and highly strung when he is in the city but
not when he lives in the Deep Cove area. His chief concern is nuclear
war. He has had a steady girlfriend for 5 years. When he drinks he
smokes 20 cigarettes a day but not otherwise.

PHYSICAL EXAMINATION:

 Mr. Neil came to the office for his examination and after
he was undressed he left hurriedly later explaining that he had to catch
a plane. He returned for examination on June 10 and was intoxicated.
He is well developed, well nourished and looks healthy. He was pleasant
and cooperative. He wears an upper denture; there are no other abnormal-
ities on examination of the head or neck. There are no abnormalities on
examination of the thoracic cage, axillary nodes, lungs or heart. B.P.
160/90 mm.Hg.

 He moves the abdominal wall well. There is no spasm
of the upper portions of the rectus muscles or tenderness in the epi-
gastrium. The liver edge is palpable 4 fingerbreaths below the costal
margin on inspiration, is round and firm; the spleen is enlarged by
percussion but could not be felt. There is no distention of veins in
the upper anterior abdominal wall. The colon felt normal; there are no
other abnormalities on examination of the abdomen. Digital examination
of the rectum revealed no abnormalities and sigmoidoscopy to 25 cm
revealed slight hyperemia; biopsies were taken 13 and 6 cm. from the anus.

Fig. 250. Miraculous effect of Montgolfier Balloons

al Neil '83

Mind and Body

There is evidence of muscle atrophy of the trunk.
There are no abnormalities on examination of the neurological or peripheral
vascular systems.

LABORATORY DATA:

Urine - pH 5.0, S.G. 1.001, sugar-negative, protein-
neative, acetone-negative, w.b.c.-negat-
@.b.c.-negative, epith-negative, bacter-
negative, casts-negative, crystals-ne

Blood - hemoglobin 14.3 gms.%., w.b.c. 12,150/cu.mm.
differential - polys 43, staphs 1, lymphs 43,
moncs 4, eos 9
smear - occasional macrocyte
STS - nonreactive
sed-rate - 19 mm./hr.

Stools - occult blood-negative (2), neutral fat-negative
(2), fatty acids-negative (2), w.b.c.-negative
(2), undigested meat fibres-negative (2).
Prov. of Health Div. of Laboratories: cultures
for intestinal parasites-negative (3); cultures
for Salmonella, Shigella and Campylobacter-
negative.

Electrocardiogram - within normal limits

Surgical Pathology report - June 9, 1983, Vancouver
General Hospital, Dr. R. Miller: Rectal
biopsy showing no histologic abnormalities.

OPINION:

Mr. Neil has cirrhosis of the liver related to alcoholism.
I advised him that if he continued to drink he would cut short his life,
and that if he stopped drinking and ate a nutritious diet, high in protein,
that there was considerable room for improvement in liver function.

Thanks again for having me see him. With best wishes,

Sincerely yours,

A. Borogh, M.D.

AB/ks
encl.

Kate Craig, *Delicate Issue*, 1979, single channel videotape (13 minutes), sponsored by Western Front Media.

Mind and Body

the origins of the voice

Nicole Gingras

Produced in 1979 by Kate Craig, *Delicate Issue* deals with questions that remain equally crucial today, namely the constant attracting and distancing of the observer's gaze; the body as cartography of public and private, or as the indirect site of voyeurism; the complex status of the feminine subject, regarded, fragmented, and videotaped; the fascination, and ultimately the obscenity, arising from the distortion or dislocation of the image.

In this video, intimacy is concealed, keenly listened for, and finally disfigured. The gaze skims over a female body, scrutinizes it, frames it in extremely tight shots. It is Craig's own body. During the shooting, the body is silent, while breath and heartbeat are perceptible. A voice-over provides the commentary: it is Craig's voice. Through this strange breach between body and voice, the artist viscerally explores the relationship, both possible and untenable, between the image and its observer.

In this way Craig questions the fragile boundary between private and public. From what distance do we see things? Does getting closer allow us to see better? Does intimacy entail the obscurity or annihilation of what is seen? Sentences are spoken and questions then asked, engaging the manifold relationships the spectator has with a work by using alternating pronouns. "How close can the camera be?" "How close do I want to be?" "How close do I want you to be?" "How close do you want to be?" "At what distance does the subject read?"

The place from which Craig speaks is a fragile threshold. The body is treated as the privileged site where views converge; it is observed to the point of being disfigured. Up close, the skin — veins, folds, wrinkles — becomes a screen to be scrutinized, a surface to be traveled. The skin is fascinating: it pulsates with breath. While the body sometimes becomes indecipherable in extreme close-up, the spectator's position is constantly challenged by the voice of the videomaker. Thus, Craig continually blurs the fascination that these often-*illegible* images might elicit, and turns the act of looking into an analytical, critical, and political activity that engages the observer.

More than Craig's other tapes, *Delicate Issue* presents the notion of confrontation between image and spectator/observer. In addition to questioning intimacy, the frontier between public and private, Craig reconfigures the boundaries that exist between intimacy and privacy. She averts the erosion of everything the body represents by presenting it as a fragmentary entity and, above all, as a "fragmentable" entity around which a voice attempts to envelop itself.

wat's untitled

Robin Blaser

Roy Kiyooka, 1926–1994, is a stunning presence in Canadian painting, photography, and poetry. During the 1960s he became dissatisfied with painting. In his own words: "I'd clobbered together a belated aspirant's modernist æsthetic, one that intrinsically denied my asian kanadian origins and those immediately around me. When all got said and done I wanted to be more immediate to the clamour and clangor of the real world." He turned to a visionary seriality, wherein one never knows in advance where one is going — while one's moment, one's image, one's thought, all are companions of another, then another — a moving world of multiplicity — astonishments of being alive, whether in joy or sorrow or in-between — the language of photography and poetry that "never stops listening 'to' and 'for' the other" — a "haunted syntax" of "diligent lovers-of-the-marvelous." We join him in his art: "i write the passages of time; mind the starlings chattering on the telephone line; hold in mind an actual world of kinship/s." This he calls "an ongoing enterprise" — and I note the lower case "i" is not a sign of humility, but a measure of one's self among things.

Roy Kiyooka, *Untitled, 1978* (triptych), courtesy Catriona Jeffries Gallery.

In this beautiful triptych of 1978, we come upon Roy Kiyooka himself, seated on both sides of the central panel — so to speak, guarding it. He holds life masks to his face, on the left, white, on the right, black. His glasses have been set aside on a small table. Masks fascinated Roy, informed by the *Noh* plays, an aspect of his Japanese heritage. Here, they are emblems of his own identity and suddenness, as if the roiling transformations of his self in his visions of time and change could now and again stop and stare — ritual mythic moments. An unused electric plug in the lower right of the left panel is not the source of the light that touches his nakedness in both panels — lustre, even in the right panel where Roy seems to scrunch down into his chair, folding into the light and darkness of mysterious life.

The central panel, so movingly guarded, is a photographic montage of several visits to a park. A sign in the upper left of the panel is carefully out of focus, leaving the place in question. The parking meters draw immediate attention. They are out-of-time — not paid-up. This pun displaces us into other dimensions, coded by the strange fact that the pole of the parking meters is seen through the sand of the first dimension of this place — two logs, a bending man, a tote bag, the rectangle of beach showers — then, to the left, a stone, a drinking fountain, a man exercising, whose back folds into the parking meter — to the right, a group at a picnic table — then, the shadowy reflection of a leafy human figure passing across the parking meter toward the first guardian — further back, a wall and distances of trees, a meadow, trees to the skyline. Intimacy and otherness, Roy speaking to us.

She doesn't desire **White Boys** over anyone else. But they keep gravitating towards her. Other men just can't **Turn Her On** in the same way.

Love Stories

Henry Tsang

Love Stories speaks about how race affects the construction of one's sexual identity and consequently, desire. The operation of desire is a complex thing. Where is its source, its locus, and how is it affected by heterosexual society? Ideals of beauty and the production of yearning complicate matters further, with their vested interests linked to the floating signifiers of economics and fashion. Throw into this mix the politics of race and the experience of racism, and the question of desire is beyond control. Relationships become more problematic; results can range from rejecting others of a similar ethnicity to developing chauvinism or exclusivity for one's own kind. Such instances serve as reminders of one's own difference, reflecting internalized or externalized racism, reflecting values that result from the tenuous relationship between your self and the world of beauty in which you live.

Henry Tsang, *Love Stories*, 2001.

Her skin was **Silky Smooth** to the touch. So is yours, she said. From then on, I began looking at **Asian women,** something I never before could do.

Henry Tsang's image was commissioned for one of five billboard posters produced by Presentation House Gallery for the Facing History Poster Project. It appeared at the Seabus Terminal in North Vancouver during the months of September and October 2001.

Chick Rice, *Sarbjit*, 2000.

Robert Keziere, *Helga Pakasaar*, 1986.

The following invitation was extended to the Vancouver art community in the summer of 1997:

Reasons for Smiles, by Esther Shalev-Gerz and Jochen Gerz, is an interactive work that will remain incomplete as long as both of the artists live. By sending an undeveloped film to the gallery address with images showing you smiling, you become a permanent part of the piece — making it change and grow.

Simply think of something that makes you smile.

There are probably as many reasons for a smile as there are people and, for all we know, these reasons are as short-lived as the smiles they produce. Indeed, there always seem to be more reasons not to smile. We smile in spite of them, as we do other things in spite of what we know. Little seems closer to us or further removed from death than a smile.

All contributions become part of REASONS FOR SMILES.

Jochen Gerz and Esther Shalev-Gerz, *Reasons for Smiles, The Vancouver Fragment* (detail), 1997, 110 framed negative b/w and colour photographs, courtesy Catriona Jeffries Gallery.

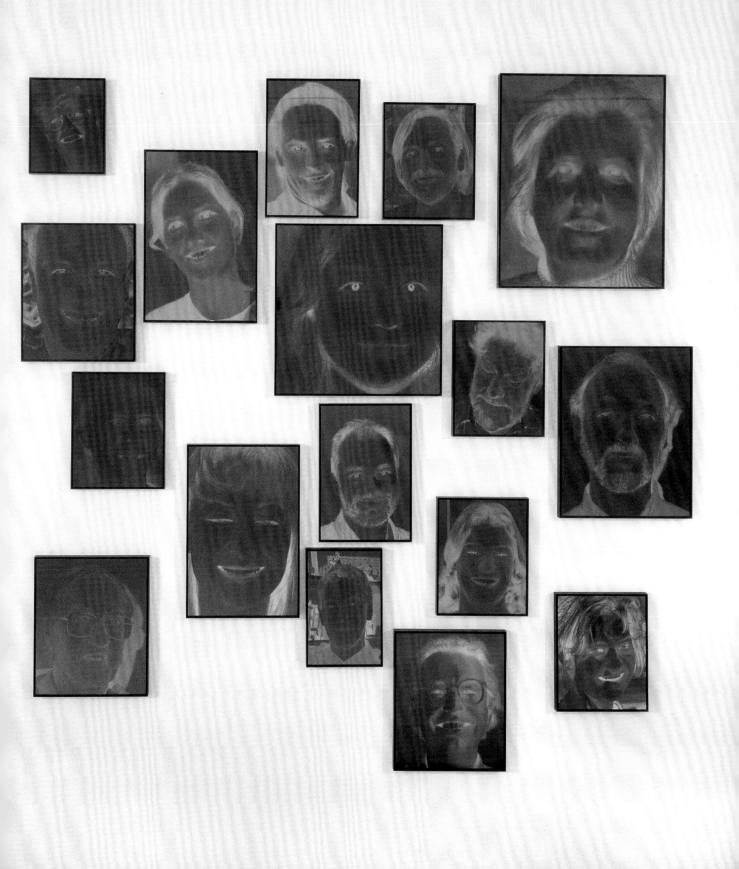

Losing Face

Tom Cone

A pulmonic effect occurred when I was sandwiched between Judy Radul's propulsive *Clapping* diptych and the humours-oozing *Reasons for Smiles* by Esther Shalev-Gerz and Jochen Gerz. One was in my face while the other was disintegrating. It was unnerving and I couldn't get a grip on either one as I found myself standing aside for Radul's focus — whoever it is, God, I'd like to know — and trying to ignore the Greek chorus on the wall. It felt like the negative portraits were draining themselves into the drywall, and all that was left were the whites of their eyes and teeth. *Reasons for Smiles* seemed like a living death, well-suited for the floor like an Etruscan mosaic, where I would be forced to negotiate from one face to another. You could work out a lot of tension on a face.

I suddenly remembered watching the original *Bodysnatchers* at too young an age, and the following day catching the measles. From then on, I connected horror movies to pain and itching. I started asking myself, would I catch something from *Reasons for Smiles*? I was worried and as I turned back to *Clapping* for comfort's sake, I looked around again for whatever the artist was standing up for. I was lost. What was happening here? I was breathing like the photos. Intensely in, out. I readied myself for the Radul. Here she comes. Right at me. "Sooner or later the philosophers' convictions take to the stage . . . 'the ass arrived, beautiful and brave.'"[1]

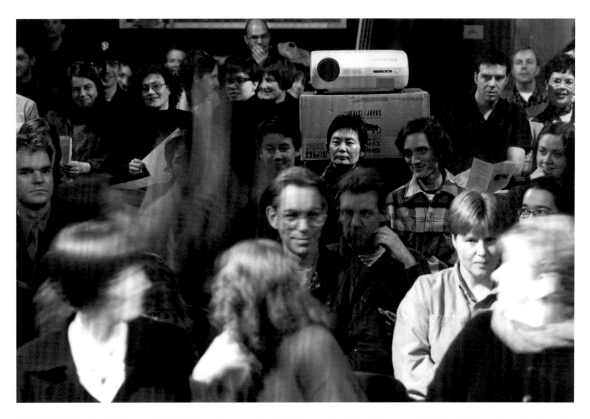

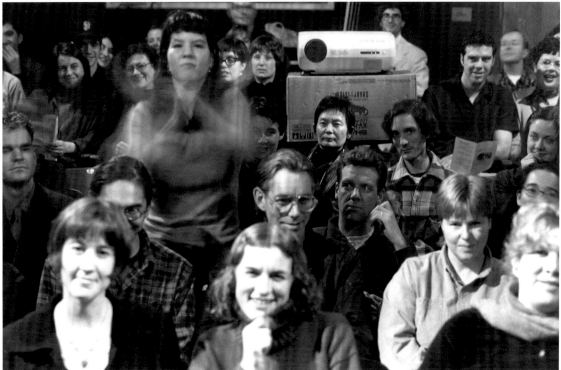

Judy Radul, *Clapping Piece: Clap until mildly exhausted*, 1/30/1998,
from *Documents for Performance* series. Photo: Fiona Bowie.

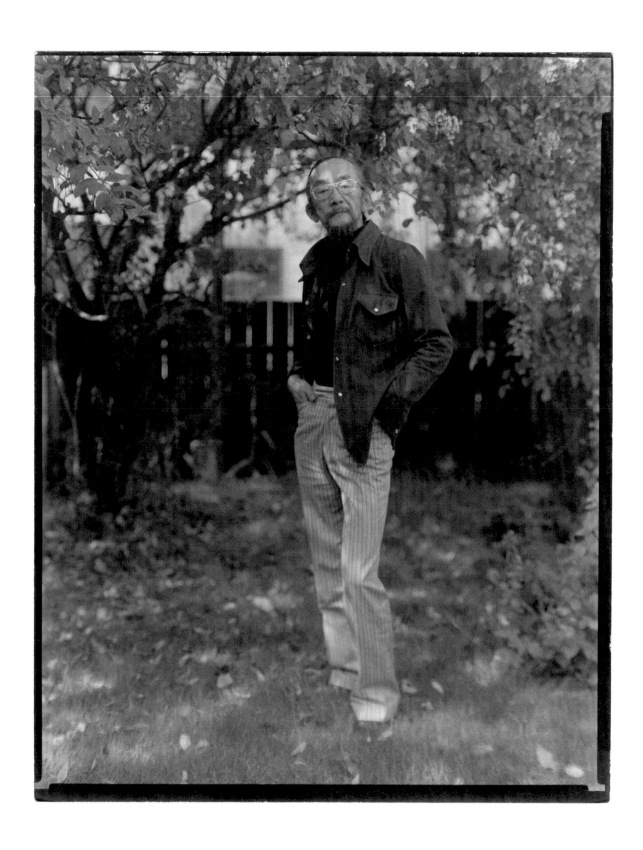

Fred Douglas, *Roy Kiyooka, artist/writer/teacher*, mid 1970s.

Visible and Unknowable

Bob Sherrin

According to art historian Norbert Schneider, between the late 1400s and the early 1600s, the portrait—as an image of a person or a group of people—becomes progressively essential in cultured European society. It serves to reinforce the revival of the individual not only through "au vif" images of royalty, of the elite of the church, and of nobles, but also through similar images of such emerging social groups as entrepreneurs, artisans, financiers, humanist academics, and artists—principally to keep them publicly visible.[1] The images were very carefully constructed, most often a collaboration between sitter and artist, in order to produce a complex and heavily coded representation. To convey the sitter's social status, interests, wealth, and political power, these portraits utilize a range of symbols: the angle of the sitter's gaze, types of fabrics present, various personal or professional accessories, background imagery, placement of males and females, even the presence of particular animals. Group portraits were often constructed to reveal similar attributes of corporate bodies such as guilds or trade associations and also to show the dynamics within the group itself.[2] One of the purposes of the portrait, however, was to move beyond the thirteenth century notion of the counterfeit image, the image that imitates, towards likenesses of particular individuals that made them identifiable in reality—almost, as Schneider points out, a form of verification asserted through the sitter and her likeness being identical.[3] Thus, what might seem to be a purely æsthetic quality in the rise of realism also begins to create a progressively more complex sense of what constitutes identity or the individualism so central to the Renaissance and to our own contemporary existence.

So, the first job of the portrait is to grant recognition—an external identity (or ID, as we say today). However, in doing so the early Renaissance portrait also produces the necessary isolation that recognition implies: it marks off the territory of individuals worthy or able to pay for such preservation. Clearly they must possess unique status, power, authority, wealth, prestige, or creativity, and common viewers of their portraits eventually learn that *we* are not *them*—emphatically not the subjects of portraiture, simply not entitled to such notice. So strong is this demand for recognition that by the early 1600s the word *portrait* is limited to images of humans, those of animals being restricted to the category of *figure* and those of plants and other non-animal forms to the category of *representation*—a redefinition of relationships which clearly indicates that individuality is the preserve of humans, males at

its pinnacle. Interestingly, this image of human superiority marks the the slow separation of western society from nature and obscures if not erases the Medieval convention that, according to Schneider, defined animals as "legal entities or 'persons'" who could be brought before a court if there was a need to.[4]

Yet even before the seventeenth century redefinition of *portrait*, such images were expected to do more than endow their subjects with recognition and identity. Near the turn of the fifteenth century, as the portrait becomes more prevalent, it is also called upon to create an atmosphere of the sitter's inner life and moral values—a psychological quality that prompts exploration by the viewer but is also directly linked to what we call identity and the identical.[5] Here the ambiguity of our language is obvious, even frustrating.

On a quick glance, any good dictionary seems to reveal that although a word's spelling may not change much over centuries, its meaning often does. However, closer exploration reveals a more complex situation: often a word's prime meaning does not change but instead is superseded by variants or different forms. Language, too, has its history, and like the history of the portrait itself, language carries more and more content over time. We might assume that this process of growth creates a more precise language, but outside specialized pursuits that create their own lexicons (snowboarders as one example, deconstructionists as another), most of us make do with a core vocabulary that has been handed down over centuries, the meanings of its words proliferating over time. Consider the word *identity*: it has roots in the word *idem* (meaning "the same"), is linked to the word *identify*, and springs from an undatable need that *The Oxford English Dictionary* claims "was felt [for] a noun of condition or quality from *idem* to express the notion of 'sameness', side by side with those of 'likeness' and 'oneness' [. . .]." So, a need to describe a human condition spawns the word *identity* which by 1981 is used in at least three disciplines and has six distinct meanings, many of which carry examples of slightly different usages. Clearly, this word hints at a complex condition: on the one hand, a striving to create exact likenesses; on the other, a state in which each human remains unique. Thus, we are each externally identifiable—the same from day to day, comparable and common. But we are also each internally unparalleled—one, different from another, not the same. Some might say this foundation—complementary or paradoxical—is an essential element in humans. And it is obvious in western notions of portraiture. From the early Renaissance onward, the portrait is expected both to create an acceptably accurate likeness and to reveal its subject's inner life. Yet the more the portrait strives to reveal the spirit, the more it becomes open to interpretation. While the symbols of guilds, religious experience, and links to antiquity may still be easily deciphered, what is the viewer to make of the sitter's other identity, her or his inner person, mood, morals? How was the sitter able to reveal them to the artist? How did the artist capture them forever in paint or marble or photographic emulsion? How does the portrait open to reveal what is least articulate?

In the late 1920s, William Friedrich Hegel demands that the portrait give "a view which emphasises the subject's general character and lasting spiritual qualities"[6]. Obviously, he links inner life with identity and identity with the portraiture of the late 1600s when, in addition to a reasonable likeness, the portrait now begins to reflect yet another Renaissance interest — that of ideal proportions. The portrait maker must do away with the flaws of nature and replace them with the "dignity and grandeur of the human being"[7]. At this point in the Renaissance the portrait must do triple duty: provide likeness and inner spirit but simultaneously create a likeness, an identifiable person, that functions as a visual metaphor for the supreme beauty and intelligence of a species. As well, this type of portrait must also contain a range of mannerisms, gestures, body postures, facial expressions, and complex gazes that reveal the intent or inner drive of the sitter. This need has an oddly contemporary goal: to "read" people in the face-to-face situations found in business and diplomacy in order to protect oneself from fraud or deception.[8] *Identity* becomes linked in a new way with *identify* — the ability to decode an individual's intentions. In fact, Michele Savonarola was only one of many writers who began to interpret what we now call body language, peering, for example, through the so-called window of the eyes to discern the true motives of one's colleagues or competitors.[9] In fact, as Schneider points out, "many of the early physiognomic hand books were composed specifically for merchants and statesmen"[10], and when these ideas were combined with the extant content of portraits, new layers of meaning were available: the body itself becomes a coded membrane, transparent to the educated, sensitive viewer.

The entire portrait, or more correctly its entire surface, thus might be seen as a larger version of that window of the eyes — but now in the form of a door that opens to a beckoning space beyond fact that cannot be occupied by any mark or gesture. Yet it seems nonetheless accessible. For the Renaissance envoy, it provided access to the identity, proclivities, soul of his opposite, his competitor, his sworn enemy. But for we who live more mundane lives in a more visual, photo-based culture, perhaps the portrait also draws us out as it draws us in. As it draws us through the image's surface, it also pulls us out and into a place where only memory, imagination, and interpretation may thrive. And where these three merge and emerge we find meaning — momentary knowledge within the unknowable, a condition both entrancing and untouchable. So, how do we find meaning, not to mention identity, through this object, this idea, this word *portrait*?

The Oxford English Dictionary offers us the following:

Portray Latin *protrahere*, meaning to draw forth, reveal, extend, prolong. Medieval Latin, meaning also to draw, portray, paint (*pro* — forth + *trahere* — to draw)

Portrait a figure drawn, painted, or carved; a representation or delineation of a person, esp. of the face made from life, by painting, drawing, photography, engraving; a likeness; something that represents, typifies, or resembles something else.

Given the above definitions, a portrait seems a very tidily limited object. And surely a photographic portrait is not merely a representation, but rather an objective delineation, proof of existence: thus namable, identifiable. Yet perhaps these definitions seem so tidy because of the logic of etymology and the certainty bestowed by an authoritative source. Could these definitions themselves be portraits—likenesses of the invisible, uneasily articulated activity that creates them? If *to portray* is *to draw forth*, what then is drawn forth? Perhaps something to be suddenly understood or revealed: a revelation. Furthermore, this process seems to extend that revelation to other unnamed levels—to specific people, things, places. As well, time is invoked. *To prolong* suggests patience, contemplation, endurance, durability. And the very need to define proposes that something is sufficiently common and sufficiently valued for us to contain it in some way so that its usefulness can be passed on relatively whole. By creating definitions, both in words and images, do we desire to fix permanently whatever is contained within the word or image? Do we want to make it visible and immobile enough to be studied, learned? If so, definitions must be intended to create in language the equivalent of an object—a fact, finite and knowable.

Interestingly, at the very source of the word *portray* are two Latin words (*pro* and *trahere*) which in themselves suggest anything but a fixed object. They hint more at movement, surely that of making a mark but also that of teasing into view something both reluctant and hidden. We may immediately sense a struggle between opponents, one pushing the other forward or *out*. We may even characterize this dynamic as a relationship between external and internal forces, which implies something akin to armies of good and evil struggling to claim a territory. But might some other dynamic also be at work among the portrait's components? Might these forces be deeply felt desires and needs, entwined and orchestrating all the variables of the infinitive *to draw* and the adverb *forth*? For within the infinitive is the momentarily definitive, the verb at work and play: are we to draw in the sense of *release*, or to draw in the sense of *sketch*, or to draw in the sense of *quickly expose to view*? How nimble is *forth*, and how nimbly from where to where? Even more energetically, all these possibilities live within the word *portray*, which itself is a verb and describes a process far more active than one we casually associate with looking at an image nailed to a wall. Ironically, our desire (or is it our need?) for precision sends us to dictionaries of all sorts in search of definitions and the certainties they seem to extend to us as gifts. Yet even such a nonchalant everyday word as *portray* now seems juiced with possibility and nuance: thus imprecise, fluid, not as easily caged as the word *definition* seemed at first to promise.

Perhaps we're similarly mobile when we're drawn to individual portraits, particularly photographic portraits because they so obviously connect us to someone or something seemingly alive, extant. We seem individually to use photographs to verify, prove, or objectify—often satisfying these needs through prolonged examination or contemplation. We thereby

take our time with these chosen photographs, these images produced with instruments calibrated by time and the passage of light through them, instruments always triggered in the irretrievable present in order to bring its past into clear, static resolution. Cameras are "clocks for seeing"[11], and they seem to freeze time into frames. They seem to delineate the present just as it becomes the past, fusing both. Yet for each of us, particular photographs are far from immobile or objective. Though they are, in fact, still life, they seem acutely alive. They do indeed seem to portray — something. And we almost always want to explain that something or narrate it, to caption it at the very least. Yet if the very language we must use to do that is rife with shades, implications, and ironies, perhaps the portrait too is both what it is and what it is not.

When asked to think of a city and a portrait, what comes to mind? More importantly, perhaps, what could a single photograph, a single portrait, reveal of such a place as Vancouver? What if Roland Barthes is correct when he says that the photograph is both sign and referent, or as he writes, "Whatever it grants to vision and whatever its manner, a photograph is always invisible: it is not it that we see"?[12] What if Barthes is correct when he claims that photography itself is transparent, that every "time I would read something about Photography, I would think of some photograph I loved, and [. . .] I saw only the referent, the desired object, the beloved body"?[13] Furthermore, what possible amalgam of photographs could portray Vancouver? How many photographs would it take to produce its portrait, fashion for it a face we could recognize and that would open so we discern its identity, inner spirit, moral values? What process of selection, exclusion, and assembly would produce such an amalgam? An even more fundamental question: what exactly would be portrayed? Who or what is the subject or sitter?

On the shelves of magazine stores across the Lower Mainland are images of Vancouver — often overlaid with the city's name and the word *portrait* rendered in Japanese, French, German, Chinese, Korean, Italian — indeed with the language of any nation whose citizens are perceived as regular tourists to southwest B.C. Likewise, similar postcards, videos, slide sets, and DVDs proliferate as Vancouver is concocted in an age of digital reproduction by the various public and private agencies concerned with the public image of the city. But what can we make of these images? What, for example, can we make of a photo on Vancouver Tourism's web site?: taken high above the east end of the downtown peninsula, looking west towards the Strait of Georgia, snow speckled mountains to the north — then forest, ocean, cloudless skies.[14] The surface of such a portrait tells us that Vancouver has a lot of buildings in the midst of beautiful geography — true of scores of cities; that some body — corporate or individual — had the money to hire a helicopter and photographer on a sunny day; that some body had the resources to reproduce the image and disseminate it as widely as possible. This particular image, and hundreds like it to be found in all media, present Vancouver — or

any other city so portrayed — in the manner of those Renaissance portraits that emphasize ideal proportions, linear perspective, and a complete lack of flaws. In this type of photograph there seems to be nothing but surface, a godlike perspective, and rarely a human in view. Those depicted are often types symbolic of leisure, pleasure, and success, and in such a narrowly focused portrait we find an absence. But in this case, the absence rarely provides a place for the interplay of imagination and memory, for in this portrait Vancouver's warmth, sophistication, or healthiness have been emphasized — all *human* attributes associated with stereotypes of the ideal, the perfect, the airbrushed, the digitally enhanced. And stereotypes actively discourage interpretation. If we are drawn to such a portrait, we may move beyond its surface to engage a generic city — idealized, sanitized, oddly dehumanized — leaving us with the reasonable perception that the city depicted is not the one we know as Vancouver. We can correctly name it, yet its identity slips away into a glossy void labelled World Class. Vancouver here seems strange, both monument and monumental: static, larger than life, emulsified in a false nostalgia. For these types of images infrequently induce true nostalgia — the pain of a desire to return home. Instead, they offer the pathology of wanting what never existed — something akin to perfection and the paralysis essential to its maintenance. This category of image seems, somehow, not to be a genuine portrait, for it lacks the variety and vulgarity of the truly human. Perhaps the qualities that we associate with the human, the spectrum of values and behaviour that we seek out in identity, are not accessible through such images of Vancouver. And portraits of humans too can appear similarly opaque and aggressively superficial, particularly when we detect that the image — like those of tourist boards — serves only itself: infinitely and sentimentally replicating "father," "aunt," "lover," "worker," "professional." Perhaps the promotional portrait, architectural or human, offers such scant space in which we can recall, reconstruct, and reinhabit unique environments that we tend to do what Barthes did: dismiss those images, or not even see them. In essence, we refuse them portrait status. We are loathe, or unable, to move beyond surface facts that are used merely to create an easily identifiable brand or logo. Instinctively, we turn instead to images that are transparent, that allow us to see *through* and *into*.

All portraits bring viewers face to face with history. This simple statement is based on the equally simple fact that photographs are a language, and like the handwritten words of a letter they are *marks* of someone not present. In the case of photographic portraits they are *images* of someone not present — the mark therefore of absence, as true of a portrait in a gallery as of the photo of a loved one tucked in a traveller's notebook. The less simple notion revolves around history itself being a form of portraiture, most often carried through narrative, and most commonly in the oral form. Even in highly literate cultures, oral narratives are fundamental to family and community histories, to a sense of who we are based on what we've been told about the times of our place (home) and its people. And as much as any

narrative, particularly an oral one, is open to constant change and interpretation, true history is mobile; like truth itself, it is multi-faceted, steadily transitional, open to scrutiny and reconsideration. Only fact is finite, undebatable. To face history, therefore, is to acknowledge uncertainty, both to revel in not knowing and in seeking a fugitive insight — as well as understanding that such illumination is energetic and will most likely prompt more search. Thus, research becomes a continual looking for and looking into, an ongoing combination of sightings and insights. The end point is arbitrary and will certainly be imposed in time. For it is within time, and therefore inescapably within memory and all its imaginative forms, that photographic portraits draw us. And what do we sketch within them but some form of ourselves, individual and collective entwined, momentary and impressive. Just as photographers and curators choose certain compositions, we viewers choose particular portraits because through them literally and figuratively we make something new through something old. Then we go there.

Portraits from Vancouver have travelled: the preposition from makes that obvious, though perhaps not consciously so. The distance involved is temporal, social, political, historical — thus cultural in the sense that this word has at its root notions of cultivation combined with reverence.[15] Reverence here suggests a respect for what is cultivated, both good and ill, not a blind adoration of the received — text or image. Without this type of respect, history in any form is reduced to propaganda and shifts from being a tool to a weapon. Also fundamental to this particular language is the absence of the preposition of, because now it becomes truly clear that there is no actual portrait of Vancouver, for there is no Vancouver to portray: no sitter, no subject. Yet from Vancouver have come hundreds of portraits from which each curator or viewer makes her selection, through which each viewer fashions his momentary and enveloping sense of a place and its people: place people. An odd phrase to our ears, yet this fusion is human and essential to the identity of a place. Consider what is implied by such phrases as the Burrard People, Musqueam People, Squamish People, Say Yup Counties People, Vancouver People. Their narratives live on and in places. Call it spirit, call it genius loci. In our media-saturated culture we are bombarded by thousands of images per day, and such a fusion seems impossible, if not senseless. But when given the time and the place, we will choose to contemplate a portrait from — not of — Vancouver and therein we will individually create identities for the city we collectively call home.

Imagine Kyla Mallet's head and shoulders photograph of seventeen-year-old Joon Aconley. Beside Aconley's image are her hand-written answers to thirty-six questions about herself. There are no beaches, boats, or beaming street musicians to be seen. Beyond her smile, however, and the slight asymmetry of her face are a host of questions that lead one particularly to Vancouver. What is the story behind a name visibly Asian and Caucasian? What ruminations might be prompted by her comment that racism is still an issue here and "people should be

treated equally"? Many local Asian families can trace back their presence in Vancouver for seven generations, and among them 1 July 1923 is called The Day of Humiliation. Why have the Chinese been so hated, feared, and admired here? Why did so many early families inter-marry — First Nations, Asian, European — and why so few during a later period of ninety years? Is Vancouverite status determined by geography or lifestyle or karma or income? Are these facts pertinent to Aconley? Perhaps not, but they may be to someone who contemplates her likeness. What exactly might be seen through Aconley's face and her words when she writes that the key to success is "to believe in who you are"?[16] Her portrait has now opened. Beyond lies a space for speculation about the forces that shape the history of this place, that granted recognition and enforced erasure, talked preservation and produced near extinction. Literally through this portrait exists a complex place for individual memories or imaginings. Later, this recollected image may draw forth from us a momentary identity for something as obviously there and not there as Vancouver itself. Thus, the portrait that has come *from* now lures us *to*. There in that privileged and very private place we constantly reinhabit some-thing called Vancouver through all the images that open for us. We may imagine those whose language is now remnant in the word *Kitsilano*; we may even carry that sharp, slippery knowl-edge into the city's streets and stroll among faces, perhaps even sense our interweaving nar-ratives. We sketch this history mundanely, necessarily, and constantly through the words and images we draw from ourselves. Through an actual portrait of Joon Aconley, for example, we might individually re-experience the human — if not entirely humane — values, spirits, morals that grant a transient certainty to the name Vancouver. However often this experience occurs, Vancouver will be mirage-like but palpable: the least visible but most mesmerizing quality of any portrait.

In the end another beginning, found in a book: a photograph dated 1876 that docu-ments Gastown, or Granville: is this Vancouver? It is certainly one of the earliest images of what would become our city, but 126 years later it beckons us into a fiction of the destroyed fact it documents. The image is of a dirt street through a village, each prominent post and building numbered and identified in a lateral index below the photograph — done perhaps by Major Matthews himself, the city's first archivist. Of the four people who sat on the Deighton Hotel verandah late on a summer afternoon, the index offers a word. Trace upward, however, from the number 13 and the word *Children*, and there they are — or were or both? — huddled against what might be Sullivan's store.[17] But if this image is a portrait, it opens not to further thoughts about what is so evidently not in Maple Tree Square today, but to the trail that in 1876 disappears beyond Portuguese Joe's place into untouched first growth forest. Who lives there? Where is their mark? What do they think of this place now or then? What can we make of this moment?

[1] Schneider, Norbert, *The Art of the Portrait: Masterpieces of European Portrait-Painting, 1420–1670*. Trans. Iain Galbraith; Koln: Benedikt Taschen, 1994, p. 6. [2–10] Schneider, p. 6–19. [11] Barthes, Roland, *Camera Lucida*. Trans. Richard Howard; New York: Hill and Wang, 1981, p. 15. [12–13] Barthes, p. 6. [14] Tourism Vancouver. *Visit Vancouver*. 9 Feb. 2002. <www.tourismvancouver.org/docs/visit/about_vancouver/intro.html> [15] *The English Oxford Dictionary*, 1981 ed., Compact. [16] Mallet, Kyla, *Legendary Teens*, C-print and 2-page questionnaire, 1999. [17] Matthews, J.S., *Early Vancouver: Narratives of Pioneers of Vancouver, BC, Collected during 1931–1932*. Vancouver: NP, 1932. B.

Works Consulted

Altitude Publishing, *Portrait of Vancouver*. Vancouver: Altitude Publishing, 2001. Text by Constance Brissenden. **Beck**, Claudia, "Through the Looking Glass: Vancouver Photography in the Seventies," *Vancouver: Art and Artists 1931–1983*. Ed. Norah Kembar; Vancouver: Vancouver Art Gallery, 1983, pp. 274–85. **Birrell**, Andrew, "Survey Photography in British Columbia, 1858–1900," Schwartz, Joan M., ed., *The Past in Focus: Photography & British Columbia, 1858–1914. BC Studies* 52 (Winter 1981–82), pp. 39–60. **Blackman**, Margaret B., "'Copying People': Northwest Coast Native Response to Early Photography," Schwartz, pp. 86–112. **Calinescu**, Matei, *Rereading*. New Haven, NH: Yale University Press, 1993. **Davison**, J. Robert, "Turning a Blind Eye: the Historian's Use of Photographs," Schwartz, pp. 16–38. **Francis**, Daniel, *Copying People: Photographing BC First Nations, 1860–1940*. Saskatoon, SK: Fifth House, 1996. **Fraser**, Simon, "From *Journals and Letters: Thompson River to the Strait of Georgia*," *Genius of Place: Writing about British Columbia*. Eds. David Stouck and Myler Wilkinson. Vancouver: Polestar, 2000, pp. 51–70. **Jacobs**, Jane. Interview with Jim Kunstler. *Metropolis*. 6 Sept. 2000. 1 Feb. 2002 <www.kunstler.com/mags_jacobs1.htm> **Janis**, Eugenia Parry, "Portraiture," *Reading into Photography: Selected Essays, 1959–1980*. Eds. Thomas F. Barrow, Shelley Armitage, and William E. Tydeman; Albuquerque, NM: University of New Mexico Press, 1982, pp. 179–92. **Kane**, Paul, "From *Wanderings of an Artist*," *Genius of Place: Writing about British Columbia*. Eds. David Stouck and Myler Wilkinson; Vancouver: Polestar, 2000, pp. 71–80. **Pakasaar**, Helga, "Formulas for the Picturesque: Vancouver Pictorialist Photography 1939–45," *Vancouver: Art and Artists 1931–1983*. Ed. Norah Kembar; Vancouver: Vancouver Art Gallery, 1983, pp. 49–55. **Schwartz**, Joan M., ed., *The Past in Focus: Photography & British Columbia, 1858–1914. BC Studies* 52 (Winter 1981–82); A special edition of *BC Studies*. **Schwartz**, Joan M., ed., "The Past in Focus: Photography and British Columbia, 1858–1914," Schwartz, pp. 5–15. **Yates**, Frances A, *The Art of Memory*. London: Pimlico, 1992.

Carol Sawyer, *Three-Headed Vessel*, 1992, silver gelatin print from pieced negative.

Biographical Notes

Artists

Anonymous photographs from various archives are unattributed and sometimes without dates (Vancouver Art Gallery, Vancouver Public Library, Pacific Newspaper Group). **Alvin Armstrong** (deceased) was the still photographer at CBC Vancouver from 1954 to 1973, and took thousands of images, primarily production stills of locally-produced studio television shows (pp. 8, 42, 45, 66, 80, 83, 119, 154). **Glenn Baglo**, recipient of National Newspaper Awards in 1970 and 1971, has worked as a *Vancouver Sun* photographer since 1970 (p. 111). **Doug Ball** (Canadian Press) is famous for his photo of Pierre Trudeau doing a pirouette behind Queen Elizabeth, for which he won a National Newspaper Award in 1977 (p. 105). **Marian Penner Bancroft**, a photo-based artist and faculty member at Emily Carr Institute of Art and Design, whose series *For Dennis and Susan: Running Arms to a Civil War* became a benchmark for the 1970's, continues in her work to address the intersection of family, culture, language and landscape (p. 17). **Percy Bentley** (1882–1968), was a British photographer who arrived in Canada in 1910 and became active, as juror and exhibitor, in the international pictorialist salons of the 1930s and 40s; through the Dominion Photo Company, which he founded in 1918, he took thousands of photographs of all aspects of Vancouver life (pp. 7, 9, 10, 85, 86). A native of B.C. who ultimately returned to this area, **Natalie Brettschneider** (1896–1986) was an innovative artist who lived her early adult years in Europe, creating musical compositions, writings, performances, and visual art (p. 54). **David Buchan** (1950–1994) was a provocative performance and visual artist in Toronto, where he was very active in the vibrant Queen Street West community; he mounted performances and exhibitions internationally and had professional links to Vancouver (p. 74). **Allyson Clay**'s practice variably utilizes painting, photography, text, drawing and technological devices to investigate urban subjectivity and agency; she is Associate Professor of Visual Art at Simon Fraser University (pp. 122–23). **Corrine Corry**, a former producer for National Film Board/CBC and currently the Director/Curator at the Richmond Art Gallery, is a multimedia artist whose lenticular cards are part of a major installation, *The Palace of the Queen*, 1987 (p. 23). **Kate Craig** (1947–2002) was a founding member of the Western Front, a co-founder of the Canadian Shadow Players, and of the 'Ettes,' a women's performance group, and a producer of video works by other artists; she was an early video art practitioner whose work continues to be influential (p. 128). **Bill Cunningham**, as staff photographer for the *Province* newspaper from the late 1940s to the mid 70s, attended to a wide range of subject matter, from political events and celebrities to the simple details of everyday life; he was the only photographer to document Pierre Trudeau's wedding to Margaret Sinclair in North Vancouver (pp. 9, 69, 79, 81, 96, 102, 124). **Max Dean** is a Vancouver native who, for 30 years, has created media-based performances and installations involving active viewer participation which profoundly affects the outcome of the work; a long-time resident of Toronto, his work was included in the Venice Biennales of 1999 and 2001 (pp. 120–21). **Diane Evans** is a photographer, a teacher at Emily Carr Institute of Art and Design, and the Gallery Coordinator at Presentation House Gallery since 1988 (pp. 28, 72). **Fred Douglas** is a photographer and writer interested in the narrative relationship between images and text; he was a staff photographer for the Vancouver Art Gallery in the early 1970s, and a member of the Leonard Frank Memorial Society of Documentary Photographers, c. 1972–74 (pp. 91, 93, 140). **Jochen Gerz** is a German artist living in Paris who has been visiting Canada's west coast since the 1970s; a recipient of prestigious awards, his public art, performances,

and installations involve an active relationship between the artist and viewer (p. 137). **John Helcermanas** was the general manager of Pacific Photographic Services in West Vancouver in the 1970s, and was periodically hired as a photographer for Burrard Dry Docks & Co. (p. 97). Little is known about **Lee Holt**, who was a photojournalist in the 1950s (p. 29). **Art Jones**, still active as a consultant, was a leading photojournalist with the *Vancouver Sun* in the 1940s, a film and television producer in the 50s, owner of the studio *Artray*, and a founder of CHAN-TV (known recently as BCTV, now Global) and later of the Panorama and Hollyburn Film Studios (pp. 39, 56–57, 87, 154). **Brian Kent** (deceased) was a staff photographer for the *Vancouver Sun* for 39 years from 1954 to 1993 (p. 103). **Robert Keziere**, the official photographer on the inaugural Greenpeace trip to Amchitka in 1971, was formerly the chief photographer at the Vancouver Art Gallery and for the past 20 years has run a freelance business specializing in the photography of art (pp. 99, 135). **Roy Kiyooka** (1926–94) was one of Canada's first multi-disciplinary artists who worked as a painter, sculptor, poet, teacher at the University of British Columbia, musician, filmmaker, and photographer; since his death he has been the focus of a major conference at UBC and several publications including the recent *All Amazed: For Roy Kiyooka* (2002) (pp. 108–09, 130–31). **Una Knox**'s photography was included in *Beyond Terminal City* at the VYO Gallery in London, UK and will be in TANK magazine, both in 2002; she was the primary photographer for Douglas Coupland's book, *City of Glass* (2001) (p. 76). **Mike Love** is a fourth-year student at Emily Carr Institute of Art and Design, specializing in photography (p. 84). **Kyla Mallett** is an artist who works with photography and text to create serial projects which are narrative in nature, investigate the inner lives of their subjects, and at times, with an acknowledgement of Vancouver's "Hollywood North" status, reference the influence of the cinematic gesture; she is currently undertaking an MFA at the University of British Columbia (pp. 36–37). **Elizabeth MacKenzie**'s work in video, multi-media installations, and drawing has been characterized by an interest in representations of maternal ambivalence, expressions of the psyche and notions of the parasite; she maintains an ongoing commitment to collaboration, writing and teaching (p. 26). **Arnaud Maggs** is an artist residing in Toronto who has photographed many Vancouver artists; while renowned for his enormous body of portraiture projects made through the 1970s and 80s, he has focused in recent years on projects that look at the traces of human loss (pp. 46–47). **John McGinnis** was general manager of Pacific Engravers and Photographers in Vancouver, and was occasionally hired by Burrard Dry Docks & Co in North Vancouver (pp. 2, 75). **Al McWilliams** works with beeswax, lead, glass, photography, and other materials to create wall-sculptures which investigate language and gender relations, the body and consciousness; he has also completed a number of major public art commissions including a recent work for the Landmark Mews Project in Vancouver (pp. 24–25). **Robert Minden**'s early photography includes the book *Steveston* with poems by Daphne Marlatt (republished 2001); later documentaries focus on portraits of family arrangements; he tours internationally as an experimental musician-composer with singer-songwriter Carla Hallett (pp. 14, 89, 153). **James Nicholas** is a Rock Cree orator, writer, and actor who has collaborated with artists Loretta Todd, Dana Claxton, and his partner Sandra Semchuk (pp. 112–13). **Al Neil**, collage artist and jazz innovator, is the founder of the legendary Cellar Jazz Club in Vancouver (1956), author of the novel *Changes: An Autobiography* (1975) and the extraordinary book of short stories, *Slammer* (1980), and the subject of David Rimmer's film *Al Neil: A Portrait* (1979) (pp. 125–27). **N.E. Thing Co. Ltd.** (1966–78) was an influential conceptual art collaboration by Ingrid and Iain Baxter, who defied traditional notions of art with innovation and humour, questioning our perceptions and merging art with the everyday; Iain Baxter continues his art in Windsor, Ontario (p. 49). **Wendy Oberlander** is a video artist and educator whose video *Still (Stille)* (2001) was preceded by the documentary *Nothing to be Written Here* (1996), a vivid and personal essay telling the story of the internment of European Jewish refugees in Canada during World War II (p. 18). **Ann Park** is an Emily Carr Institute of Art and Design photography student who recently worked as a translator for publications in South Korea (p. 88). **Jerry Pethick**, a multi-media artist, co-founder of the School for Holography

Robert Minden, *Three Women, New Denver*, 1973, from the book *Steveston* by Daphne Marlatt
and Robert Minden, Ronsdale Press, 2001 (first published in 1974 by Talonbooks).

Top: Art Jones/Artray, *Chief Joe Mathias with 1937 Packard, North Vancouver*, March 1950, courtesy Vancouver Public Library/Special Collections [81186-A]. Bottom: Alvin Armstrong, *Wide, Wide World* (The Seaforth Highlanders performing regimental manœuvres "British Hollow Square" and "Thin Red Line,") November 27, 1955, production still, courtesy CBC Vancouver.

in San Francisco in 1971, and recipient of the Claudia de Heuck Fellowship at the National Gallery of Canada (1999), investigates space, optical phenomena and perception to creative innovative, often witty installation works (p. 51). **Colin Price** has been working as a staff photographer at the *Province* newspaper since 1973 (p. 104). **Foncie Pulice**, operator of "Electric Photos" from 1946−79 at Granville and Robson Streets, is reported to have taken over 20 million street photographs with a camera made from war surplus material and powered by a car battery (pp. 60, 63). **Judy Radul** is an artist, teacher, and writer whose practice, which includes live actions, video, installation art, photography, and audio works, is based in part on a consideration of forms of performance including everyday behaviour (pp. 70−71, 139). **Chick Rice** has taken photographs of people for decades, as a commercial photographer and as an artist whose work is highly regarded for its remarkably complex investigation of the human psyche (pp. 4, 134). A photographer, teacher, and photographic historian, **Henri Robideau** is renowned for his two-decade-long project *The Pancanadienne Gianthropological Survey*, and for his narrative images of the epic drama of everyday life (pp. 94−95). **Carol Sawyer** is a visual artist and singer who makes photographs, multi-media installations, musical performances, and interdisciplinary performance works (pp. 52, 150). **Sandra Semchuk** is a Canadian of Ukrainian Polish origins, teacher at Emily Carr Institute of Art and Design, and a photographer and installation artist whose primary concerns address story and collaboration as the basis for dialogue and recognition across cultures and species (pp. 101, 112−13). **Esther Shalev Gerz** has been living in Paris since 1984; for over 20 years her work has centred on interventions and projects in public space, taking form via collaboration and exchange with the audience, and raising questions about group memory and its interaction with personal history and the souvenir (p. 137). **George Smith**, unknown photographer (p. 116). **Michèle Smith** is a photography major at Emily Carr Institute of Art and Design who recently completed a semester studying at the École Nationale Supérieure des Beaux-Arts in Paris, France (pp. 64, 65). **Henry Tsang** is an artist and occasional curator who works in installation, video, performance, and photo-based installation; he participated in *On Location: Public Art for the New Millenium* at the Vancouver Art Gallery, and *The Mount Pleasant Golf & Country Club*, organized by the group Collective Echoes (pp. 132−33). **Jeff Wall** is an internationally renowned artist who makes large, luminous photographs, most often in light boxes, which explore social realities of contemporary life, referring to the history and language of painting, and drawing on the narrative drama of cinema (pp. 34, 35). **Ian Wallace** is a teacher and photo-based artist who played a leading role in the development of photo-conceptualism in Vancouver; his work has strong art historical and literary references and is often a study of the individual's negotiation of the modern city (pp. 58, 59). **Colette Whiten** teaches at the Ontario College of Art in Toronto, and as an artist has produced needlework projects, since 1985, which are often sculptural in nature and address issues of power and representation (p. 53). **Paul Wong** is a founding director of Video In Studio and On Edge Productions, and an interdisciplinary and multimedia artist best known for his video projects dealing with issues of race, sexuality, and identity (pp. 40−41). A professor at Simon Fraser University, **Jin-me Yoon** is a video and photo-based artist whose work critically and ironically questions the systems of representation which reflect, conflict with and affect identity (pp. 20−21). **Sharyn Yuen** is a co-founder of Paper Ya and a photo-based artist trained in Japanese and European papermaking traditions; her work addresses issues of racism and identity related to the history of Chinese migration to Canada (pp. 30, 33).

Writers

Robin Blaser is a poet and former University of British Columbia teacher whose extensive work was the subject of a major conference and festival, *The Recovery of the Public World* at UBC in 1999; his recent work includes a keynote address on Dante Alighieri (1997), and the libretto for Sir Harrison Birtwistle's opera *The*

Last Supper (Berlin Staatsoper 2000) (p. 130). **Colin Browne** is a writer, filmmaker, and teacher at Simon Fraser University whose current projects include *Altar*, a short film; a feature-length screenplay titled *I'll Be Loving You*; and the recent book of poetry and performance text, *Ground Water* (2002) (p. 67). **Wayde Compton** is a poet and cultural critic whose book *49th Parallel Psalm* was shortlisted for the Dorothy Livesay Poetry Prize; he also edited *Bluesprint: Black British Columbian Literature and Orature*, 2002 (p. 82). **Tom Cone** is a playwright (p. 138). **Nicole Gingras**, a writer and an independent curator living in Montréal, is interested in experimental approaches to film, video, and digital art, and has curated many film and video programs, solo and group exhibitions which have toured Canada and Europe (p. 129). **Bruce Grenville**, currently the Senior Curator at the Vancouver Art Gallery, has written for many art periodicals and catalogues; his recent project *The Uncanny: Experiments in Cyborg Culture* is a book (2002) and VAG exhibition that will tour North America (p. 19). **Karen Henry** is an independent curator, editor and writer who, having completed a documentary video on curator / writer Doris Shadbolt (2002), is currently working on a book about Shadbolt's major contribution to Canadian art, and a touring survey exhibition on the work of Allyson Clay (p. 122). **Robert Hunter** is a founder of Greenpeace and former columnist for the *Vancouver Sun*; he is currently based in Toronto where he is host for the morning commentary show "Paper Cuts," and the ecology specialist for City-TV (p. 98). **Brian Jungen** is a multi-media practitioner who explores what it means to be a Native contemporary artist in Canada, often by re-crafting prefabricated materials to create new meaning in sculptural form (p. 107). **Russell Keziere** is a software marketing executive and occasional poet, travel writer, and art critic based in Cambridge, Massachusetts; he was publisher and editor of *Vanguard* magazine from 1978 to 1989 (p. 73). Born in Harare, Zimbabwe, of Chinese origin, **Laiwan** was founder of the Or Gallery in 1983, and is a writer and interdisciplinary artist who has been researching the epistemological shift found in digital technologies and the disappearance of older cultures (p. 31). **Karen Love** is an independent curator and editor who was the Director / Curator of Presentation House Gallery from 1983 to 2001; she was co-curator, with Karen Henry, of the international project *War Zones* (1999) and is currently developing a project about wanderlust and the 'wanderkammer' (p. 11). **Liz Magor** is a teacher at Emily Carr Institute of Art and Design, and an artist working in photography and sculpture who was a finalist for the National Gallery of Canada's prestigious *Elusive Paradise, The Millennium Prize* in 2001; a solo survey exhibition of her work will be co-produced by the Vancouver Art Gallery and the Power Plant in Toronto (late 2002 / 2003) (p. 22). **Roy Miki** is an award-winning writer, poet, critic, and teacher at Simon Fraser University, whose books include *Justice in Our Time: The Japanese Canadian Redress Settlement* (with Cassandra Kobayashi), 1991, *Random Access File*, 1995, *Broken Entries: Race, Subjectivity, Writing*, 1998, and *Surrender*, 2001 (p. 110). **Sarah Milroy**, formerly of Vancouver, now lives in Toronto where she is the visual arts critic for the *Globe and Mail*; from 1991 to 1996, she served as editor and publisher of *Canadian Art* magazine, and has more recently contributed an essay to the book, *Greg Curnoe: Life & Stuff* (2000) (p. 90). **John O'Brian** teaches art history at the University of British Columbia, and is a co-founder and publisher of *Collapse: the View From Here*, a periodical published by the Vancouver Art Forum Society, the author or editor of 11 books and a co-editor of *All Amazed: For Roy Kiyooka* (2002) (p. 78). **Helga Pakasaar**, formerly the Curator of Contemporary Art at the Art Gallery of Windsor, is currently an independent curator and writer who has worked on numerous projects about little-known photo archives, including the Presentation House Gallery exhibition *The Just Past of Photography in Vancouver* (p. 61). Founder of *C* Magazine in 1983, **Richard Rhodes** has been the editor of *Canadian Art* magazine since 1996; he is also a writer, teacher and curator whose most recent publication is the children's book *A First Book of Canadian Art* (2001) (p. 43). **Marina Roy**, who teaches in Fine Art at the University of British Columbia and whose practice includes sculpture, painting, printmaking, photography, and bookworks, is also a writer and the author of *sign after the X* (2001) (p. 77). Since 1998, artist **Carol Sawyer** has worked to reconstruct Natalie Brettschneider's performances from the original documentation and first-hand accounts; she has given two performances of

Brettschneider's musical repertoire, and an essay summarizing her research findings has been published (2001) (p. 55). **Bob Sherrin** is a visual artist, author, art critic, and instructor in the Humanities Division of Capilano College, where he was editor of the *Capilano Review* from 1990 to 1998; a recent published work is a collaboration with Vancouver poet Ryan Knighton, for which Sherrin made site-specific photographs in response to Knighton's poem "Pandemonium" (p. 141). **Michael Turner**'s works of fiction include *American Whiskey Bar* and *The Pornographer's Poem*; currently he is writing a libretto for the Modern Baroque Opera's adaptation of *Max & Moritz*, as well as a screenplay (with Bruce LaBruce) based on the life and work of photographer Wilhelm Von Glœden (p. 117). A teacher in The Writer's Studio at Harbour Centre, Simon Fraser University, **Betsy Warland** is a writer of critical essays and reviews on art, editor of several literary anthologies, and has nine published books on poetry and prose, including *Bloodroot: Tracing the Untelling of Motherloss* (2000) (p. 27). **Rita Wong**, the author of a book of poems, *monkey puzzle* (1998), has worked as a writer, teacher of English, an archivist and activist, and in 1997 was the recipient of the Asian Canadian Writer's Workshop Emerging Writer Award (p. 38).

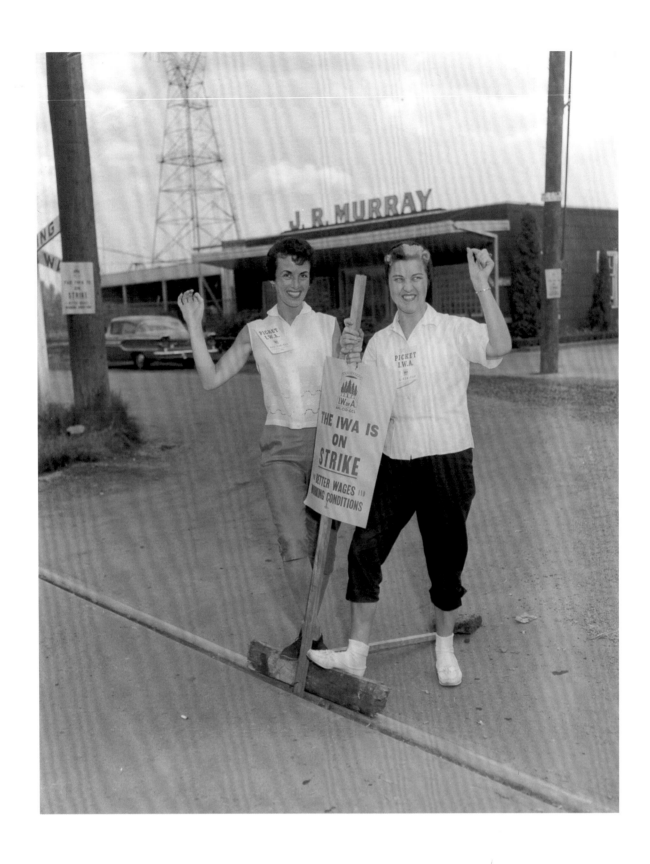

Photographer unknown/*The Province*, *IWA Strike* (Elaine Thompson and Lil Harris, J.R. Murray, Plywood Plant), 1959, courtesy Pacific Newspaper Group and Vancouver Public Library/Special Collections [41900].

Acknowledgments

Facing History: Portraits from Vancouver began its life as the 25th anniversary exhibition for Presentation House Gallery, held in the fall of 2001. Opening three days prior to September 11 and running for six weeks, the show was viewed within the vivid context of a surreal and troubling time. I was grateful, therefore, for the still-fresh memories of working with many generous individuals. My acknowledgements begin, in a related way, by reaching backwards in time to the work of several fellow curators. For many years I have valued the experience of working with Helga Pakasaar, who introduced me to the surprising resource, which all communities have, of our local photographic archives. Her exhibitions *In Transition: Postwar Photography in Vancouver* and *The Just Past of Photography in Vancouver* opened the door—for me—to a whole new world of images. The curatorial models provided by my colleagues Peter White and Rosemary Donegan have also been an inspiration. Both employ a fearless strategy of assembling images and objects from the seemingly disparate worlds of fine art, commerce, private life, history and popular culture, in order to try to comprehend a wide range of concerns and phenomena pertinent to our lives. In particular I am thankful for Peter White's project *It Pays to Play: British Columbia in Postcards, 1950–1980* and for Rosemary Donegan's exhibition *Work, Weather and the Grid: Agriculture in Saskatchewan*.

I wish to extend my appreciation, for the *Facing History* endeavour, to those who helped me find and weave my way through thousands of photographs, in particular: Kate Bird, Librarian at the Pacific Newspaper Group; Diane Evans, in her role as instructor at Emily Carr Institute of Art and Design; Wendy Godley and the Special Collections team at the Vancouver Public Library; Catriona Jeffries, Catriona Jeffries Gallery; Francis Mansbridge, Archivist at the North Vancouver Museum and Archives; Trevor Mills, Chief Photographer at the Vancouver Art Gallery; and Colin Preston, Archivist at CBC Vancouver. In addition to securing loans from these institutions we were pleased to borrow work from other sources, and were assisted in this by Rojeanne and Jim Allworth; Heather Buchan (with help from A.A. Bronson and Art Metropole); the Cunningham family, especially Clare Burrows and Dan Cunningham; Liane Davison, Curator at the Surrey Art Gallery; Bruce Grenville, Senior Curator at the Vancouver Art Gallery; Susan Hobbs, Susan Hobbs Gallery; Robert Hunter; Sandra Parent; Dale Steele; Andy Sylvester, Equinox Gallery; Baiba Thompson; and Scott Watson. The *Facing History* exhibition was presented with assistance from the former Interim Director at Presentation House Gallery, Denis Gautier, and the stellar team of Diane Evans, Linda Chinfen, Geoffrey Farmer, Dennis Kulpas, Marie Lopes, Jonathan Mills, Ann Park, Chris Frey, and Deborah Murray. We are deeply indebted to the many sponsors of the project (listed on the following page), who made all of this financially possible.

With respect to the book, it has been an enormous pleasure to work again with the fabulous ensemble at Arsenal Pulp Press. Blaine Kyllo, Robert Ballantyne, Kiran Gill Judge, and especially Brian Lam provided a climate of *faith*, generosity and sweet good reason. Thanks are due also to Bill Jeffries, Director at PHG, for supporting this inherited project, and to Jennifer Love and Karen Henry. Mark Timmings of Timmings & Debay contributed his award-winning talent and patience to produce an elegant design. David Clausen created gorgeous duotone scans and assisted with the fine-tuning of colour scans. And throughout the project, I benefited from and am grateful for the steadfast and uncompromising good eyes and ears of Robert Keziere. I wish to thank the writers for accepting my somewhat unusual challenge and completing the task with passion and clarity. And finally, where it all begins, I extend my appreciation to the image-makers who continue to creatively reflect and respond to the world in which we all live. —KL

Facing History: Portraits from Vancouver is sponsored by the Canada Council for the Arts; the British Columbia Arts Council through the Ministry of Community, Aboriginal and Women's Service; the British Columbia Heritage Trust; the Greater Vancouver Regional District; the North Shore Arts Commission; the District of North Vancouver; the City of North Vancouver; The Vancouver Foundation; The Christopher Foundation; File Bitapart; Denbigh Design; Marine Printers; Obie Media; Opus Framing & Art Supplies; Pattison Outdoors; and Polaroid Corporation. Arsenal Pulp Press gratefully acknowledges the support of the Canada Council for the Arts and the British Columbia Arts Council for its publishing program, and the Government of Canada through the Book Publishing Industry Development Program for its publishing activities.

Publication coordination and editing by Karen Love; Editorial assistance by Brian Lam; Book design by Timmings & Debay; Installation / reproduction photography: Robert Keziere, pp. 20–21, 23, 24, 26, 36, 46, 49, 51, 53, 58, 59, 74, 94, 101, 108–09, 120–21, 125–27, 130; Trevor Mills, pp. 17, 128; Kim Clarke, p. 137; Selected scanning by David Clausen; Printed and bound in Canada by Friesens.

Endpaper photographs (details): Art Jones / Artray, *Nuns and Chinese Children in Vancouver*, 1951, courtesy Vancouver Public Library / Special Collections [82061-E]; David Buchan, *Canadian Youth*, 1988, courtesy Heather Buchan; Bill Cunningham(?) / *The Province*, *Elvis Presley fans*, 1957, courtesy Pacific Newspaper Group, Vancouver Public Library / Special Collections [61267].

Nicole Gingras, "The origins of the voice," was originally published in *Magnetic North: Canadian Experimental Video*, Winnipeg: Video Pool Inc. / Minneapolis: University of Minnesota Press, Walker Art Center, 2000.

National Library of Canada Cataloguing in Publication Data

Main entry under title: Facing history
Copublished by Presentation House Gallery
ISBN 1-55152-127-X

1. Vancouver (B.C.) — Biography — Portraits. 1. Vancouver (B.C.) — Pictorial works.
1. Love, Karen. 11. Presentation House Gallery.

FC3847.37.F32 2002 971.1'3304'0222 C2002-910831-4
F1089.5.V22F32 2002

Presentation House Gallery 333 Chesterfield Avenue,
North Vancouver, British Columbia, Canada V7M 3G9 *www.presentationhousegall.com*

Arsenal Pulp Press 103–1014 Homer Street,
Vancouver, British Columbia, Canada V6B 2W9 *www.arsenalpulp.com*